SAATCHI GALLERY

THE TRIUMPH OF PAINTING

ALBERT OEHLEN
THOMAS SCHEIBITZ
WILHELM SASNAL
KAI ALTHOFF
DIRK SKREBER
FRANZ ACKERMANN

The Mnemonic Function of the Painted Image Alison M. Gingeras

'Not being remembered at all: this has, in the end, been the fate of the subjects of most photographs.'
Geoffrey Batchen

The desire to ensnare and preserve memory is a fundamental human pursuit. Photography, with its capacity to depict the world indexically, long seemed to surpass painting as the optimal tool for capturing the fleeting instant. Yet amid the overabundance of photographically generated images in the world today, the medium has slowly revealed its limits. The advent of photography has taught us that memory is not precise; it is nebulous, malleable, ever changing. The sharpness and precision of camera-made images conflicts with the way the human brain remembers. As photo historian Geoffrey Batchen provocatively argues, the 'straight' photograph has always been an insufficient vehicle for memory. Over the course of the medium's popularization, people have found ways to transform photographs into objects by adorning them with paint, elaborately framing them, incorporating them into jewellery or devotional objects. The aim of making these hybrid photo-objects is to 'enhance their memory capacities' through sensorial manipulation. These embellishments 'counteract the fact of death' and aid the photograph in its struggle against being forgotten by the living.[1]

Certain contemporary painters have long understood the mnemonic insufficiency of the photograph and have capitalized on their own medium's strength in this domain. The painted image, with its material sensuality, tactility, and atmospheric possibilities, corresponds more closely to the imprecision of the human brain's mnemonic functions. Memory is often triggered by the banal, by otherwise vacant or impressionistic details that prompt the senses through association. Painted images – precisely because they lack the pictorial authority and truth-telling capacity of photography – can more easily trigger a free play of association, or become a catalyst for a web of connections that relate to the viewer's own memory bank. Inverting the photograph's claim to instantaneity, the painstaking, artisanal nature of a painting's own making metaphorically relates to the mental intensity and time required by the act of reminiscence. As curator Russell Ferguson has surmised, 'with photography in command of specificity, advanced painting seeks ambiguity'.[2]

Artists such as Wilhelm Sasnal and Kai Althoff have seized on the mnemonic potential of painting to weave together hybrid tableaux, conflating personal stories and collective events. Living and working in Poland, Sasnal culls his subjects from several recurrent categories: architectural structures, organic/plant forms, portraiture (most frequently he paints his wife Anka), film stills (often appropriated from Polish cinema), album and book covers. Rarely painting from life, the camera lens is what consistently mediates Sasnal's source imagery. Sasnal's stylistic range is as varied as his sources of inspiration; in any single exhibition, his work can run the gamut of pop, photorealism, informal minimalism and gestural abstraction, among others. He uses these different painterly techniques and styles to transform and elevate his photographic source images into cryptic signs, powerful emblems and poetic pictures. Mixing the historical and personal with the random and trivial, Sasnal creates a pictorial rebus that, while accessible to the viewer, remains deeply subjective. Each picture is like a jump cut, taking the viewer back and forth in time and space, from near present to distant past, from bird's eye view to microscopic close-ups that dissipate into abstraction. This telescoping in-and-out resembles the way the human mind retains and transforms memories, converting them into a string of ever-mutating images.

Like Sasnal, the Cologne-based artist Kai Althoff's work is driven by an inextricable mélange of intimate fictions and allusions to Germany's highly charged history. Althoff channels his obsession with adolescence, homoeroticism and utopian communities into an astounding formally and materially varied oeuvre. His best-known series, entitled Impulse (2001), is drenched in narratives and imagery taken from Germany's collective memory. German folklore, Prussian military regalia, as well as Catholic mysticism have directly inspired his iconography. His compositions are mostly populated by a series of androgynous characters in period settings and dress – often illustrating the artist's own alter egos. The figures and scenes that are depicted in Impulse are rendered with great dexterity; not only do their costumes and uniforms evoke the First World War, but they strategically recall the style and draftsmanship of such early twentieth century German artists as George Grosz and Käthe Kollwitz. These stylistic borrowings are as much a self-conscious acknowledgement of art historical antecedents as it is part of Althoff's mnemonic alchemy.

Three young German artists – Franz Ackermann, Thomas Scheibitz and Dirk Skreber – combine the languages of figuration and abstraction in their painting to explore a different aspect of public memory. Less narrative and personal than Althoff or Sasnal, these three artists have each developed a unique conceptual procedure (as well as signature style) that allows them to investigate universal experience and collective consciousness. An inveterate voyager, Ackermann records his journeys around the globe in the form of

dense, pop-flavoured canvases that often incorporate sculptural elements or photographic collage. Entitling these works 'Mental Maps' or 'Evasions', Ackermann translates his physical and mental experiences into a painted atlas of a world that is both real and imagined. While his renderings contain numerous recognizable fragments – such as architectural motifs, sprawling urban plans, silhouetted skyscrapers and dynamic transportation networks – his picture planes equally contain passages of exuberant abstraction. Ackermann's shrilly fluorescent palette and undulating forms echo the fleeting impressions of the tourist/traveller who is incapable of verbalizing their experiences when they return home. Ackermann treats the canvas as a privileged site to exercise his memories, though his cartographic recollections are open-ended enough to allow the viewer to project their own urban reminiscences. In essence, on each viewing one recomposes Ackermann cartographies according to one's own experience.

By merely travelling round the corner to the newsagent's, Thomas Scheibitz has amassed a vast archive of human experience. His countless clippings of found images appropriated from the deluge of mass media publications serve as the basis of his canvases. Scheibitz takes the most banal of singular objects – a suburban house, a flower, a man's face – and formally manipulates them into semi-abstract compositions. Using a sickly, glacial palette of purples, pinks, blues, yellows and greens, Scheibitz subjects remain somewhat recognizable, though the abstraction process produces an alienating effect. Instead of romanticizing the mnemonic potential of ordinary consumer products, he uses painting to distil them into cold, cerebral objects of contemplation. Scheibitz has often compared his practice with scientific research in the area of 'public memory'. Having read about a series of experiments in which brain specialists recorded the patterns in neural activity of human subjects when hearing certain commonplace words, Scheibitz sees his choice of prosaic imagery as a similar exercise in stimulating our universal consciousness.

Dirk Skreber similarly fuels his painterly practice with collective experience, though his interest veers towards a more visceral terrain. With the saturation of twenty-four hour news channels and the endless stream of infotainment available on the Internet, the spectacle of disaster – whether natural or man-made – has become one of the most banal forms of experience in contemporary life. Painting on a monumental scale and using aerial compositional techniques that mimic the POV of surveillance cameras, Skreber portrays gruesome car crashes, floods of biblical proportion and impending train wrecks with a cold-blooded fascination. Yet unlike

Warhol, Skreber's preoccupation with death and disaster does not seem to be lifted from a mass media source. Instead, Skreber's lushly painted images of catastrophe seem to be distilled from our collective nightmares. These disembodied images are like phantom memories, not based on actual events but part of the universal experience of contemporary life.

Albert Oehlen, who occupies the dual role of 'senior' artist and agent provocateur in this loose agglomeration, uses his vast knowledge of painting's history to debase his own medium. As one of the 80s proponents of 'bad painting' (alongside Martin Kippenberger), Oehlen deliberately pillages from a repertoire of established genres, techniques and idioms to demonstrate the failures of both abstraction and figuration. As Diederich Diederichsen has written of Oehlen, 'If [he] was to rise above the contemporary criticism of painting's viability as a practice, he would have to work in the embattled medium: to create the object criticized. He wanted to do three things: to demystify the painting process, presenting it as a series of tricks and ruses; not only to present this critique but almost to 'say' it, since he believes that painting functions like and indeed is a language; and to create objects that were clearly paintings yet that could speak without illusion, and without constant mystification.'[3] In order to achieve these ambitious goals, Oehlen uses the memory of his own medium against itself, to deflate painting's own mythology in order to rebuild it anew.

Once threatened by the advent of photomechanical devices, painting has struggled against slipping into irrelevancy, in the same way that human beings grapple with the possibility of being forgotten. Yet since the contemporary viewer has become so saturated with camera-made images, hyperrealistic forms such as photography and film have become banal and ineffective. Painting has regained a privileged status. The medium's tactility, uniqueness, mythology and inherent ambiguities has allowed painting to become an open-ended vehicle for both artist and viewer to evoke personal recollections, to embody collective experience and reflect upon its own history in the age of mechanical reproduction.

1 Geoffrey Batchen *Forget Me Not: Photography and Remembrance* Van Gogh Museum, Amsterdam and Princeton Architectural Press, New York, 2004, pp. 96 - 7

2 Russell Ferguson *The Undiscovered Country* The Armand Hammer Museum of Art, Los Angeles, 2004, p. 18

3 Diederich Diederichsen 'The Rules of the Game: An interview with Albert Oehlen' *Artforum*, November 1994

PLATES

ALBERT OEHLEN
Black Rationality 1982
oil on canvas
260 x 190cm

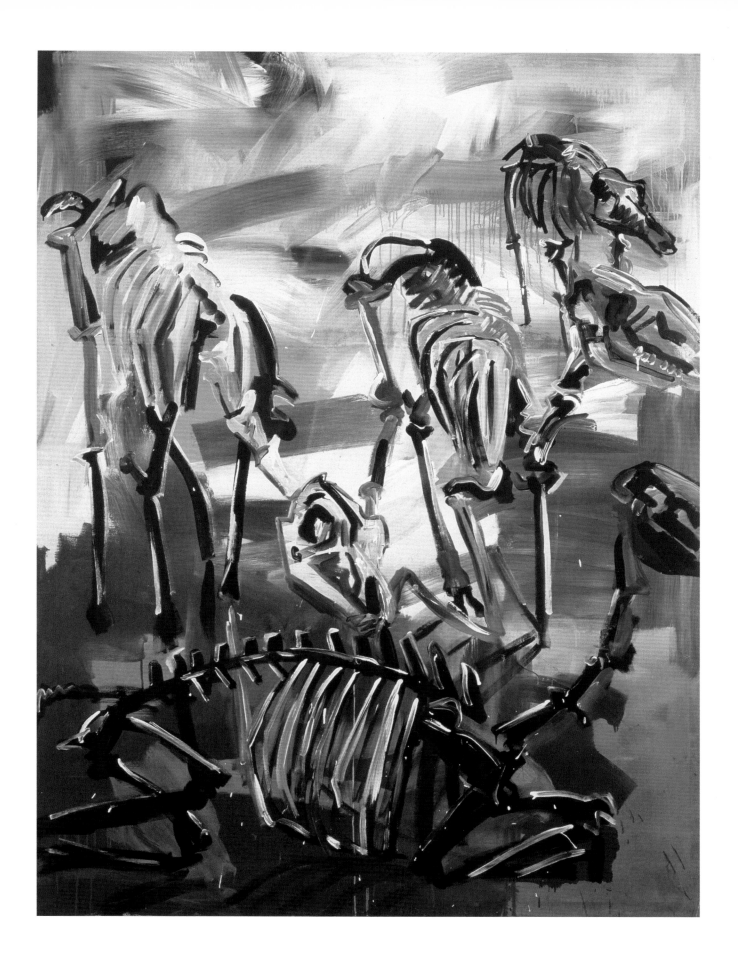

ALBERT OEHLEN
Descending Hot Rays 2003
oil on canvas
280 x 300cm

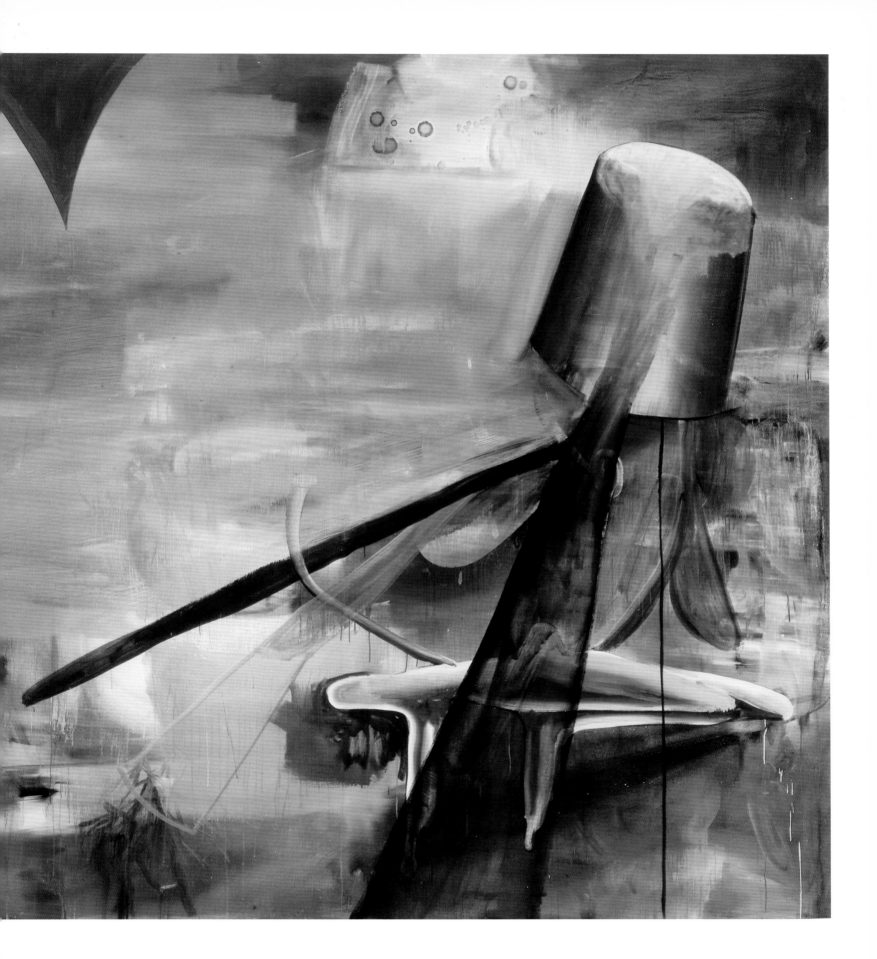

ALBERT OEHLEN
Piece 2003
oil on canvas
280 x 340cm

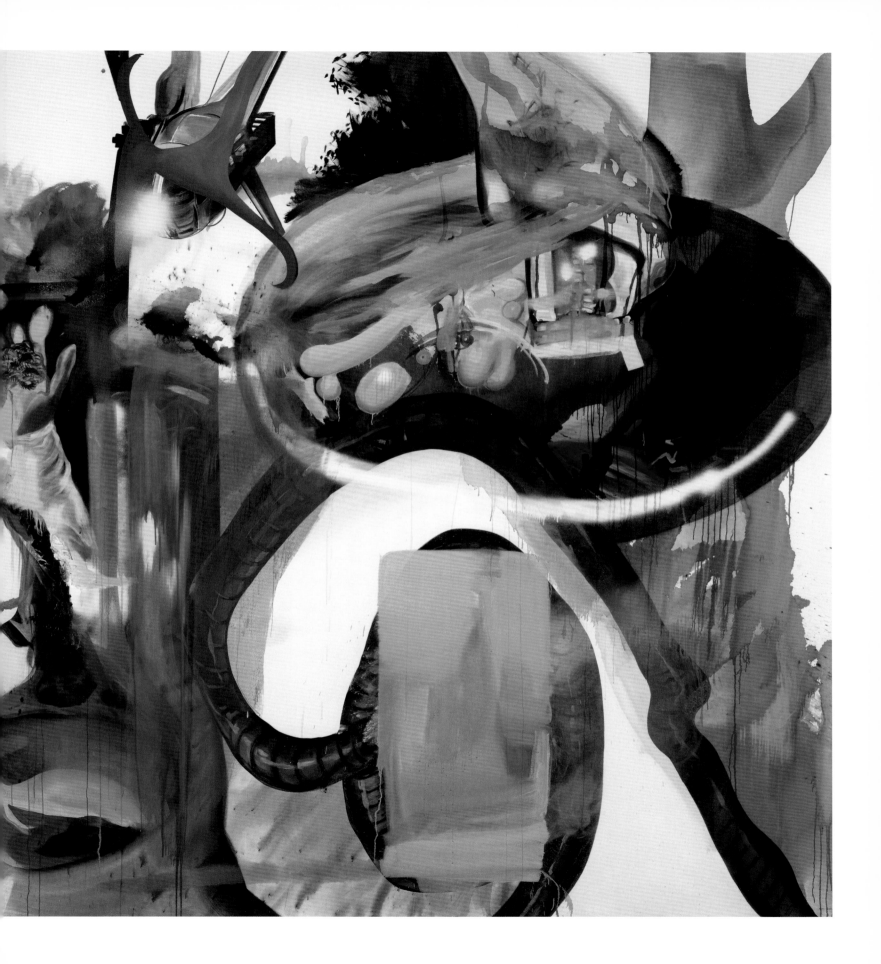

ALBERT OEHLEN
Peon 1996
oil on canvas
191.5 x 191.5cm

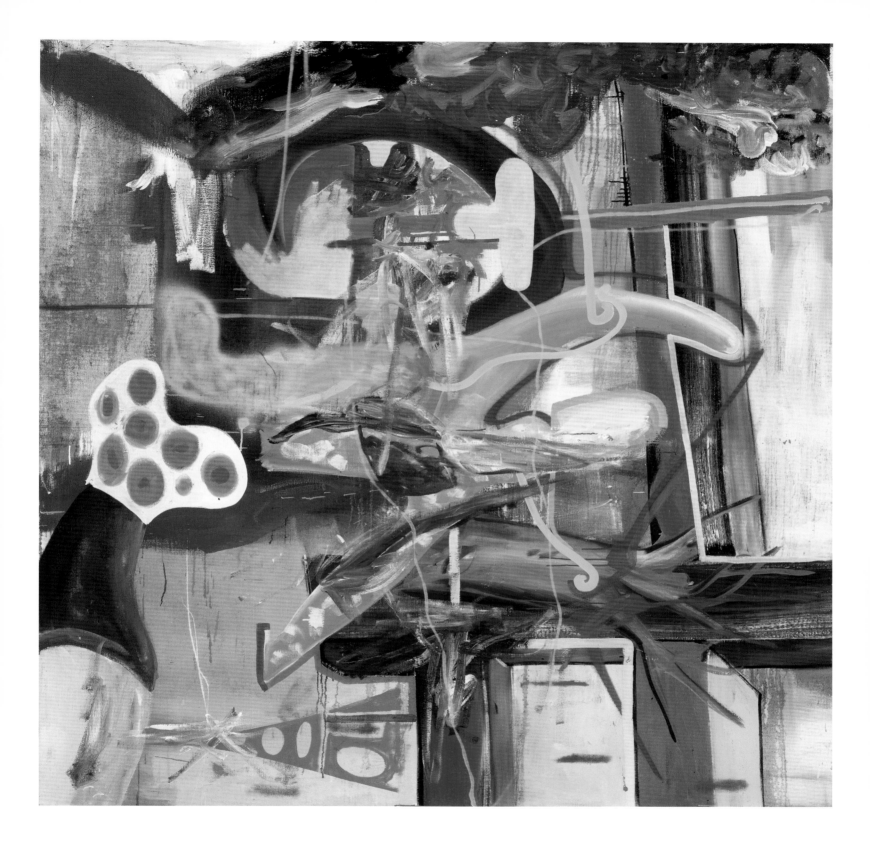

ALBERT OEHLEN
Titanium Cat with Laboratory Tested Animal 1999
oil on canvas
209 x 300cm

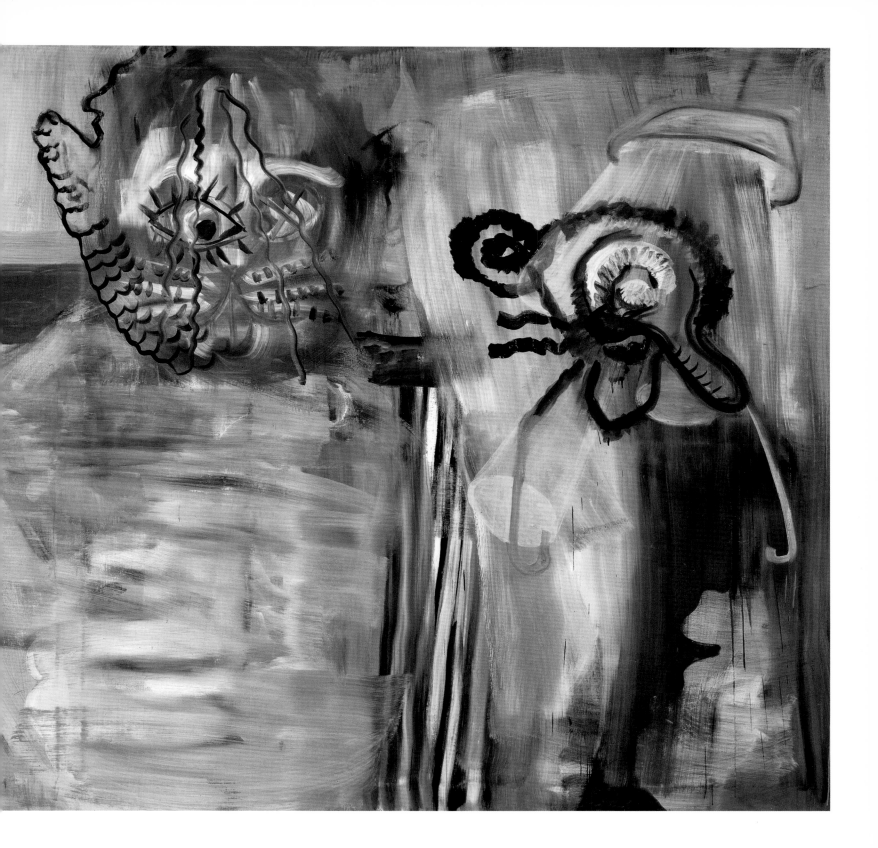

ALBERT OEHLEN
DJ Techno 2001
mixed media on canvas
360 x 340cm

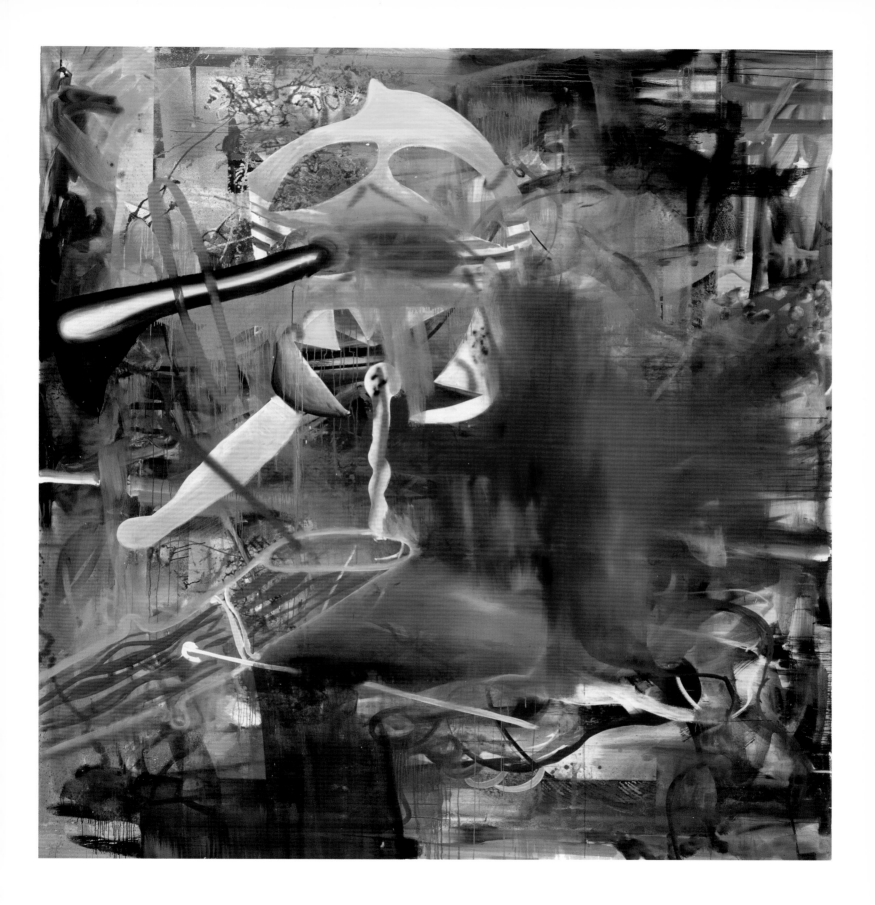

ALBERT OEHLEN
Interior 1998
oil on canvas
238 x 238cm

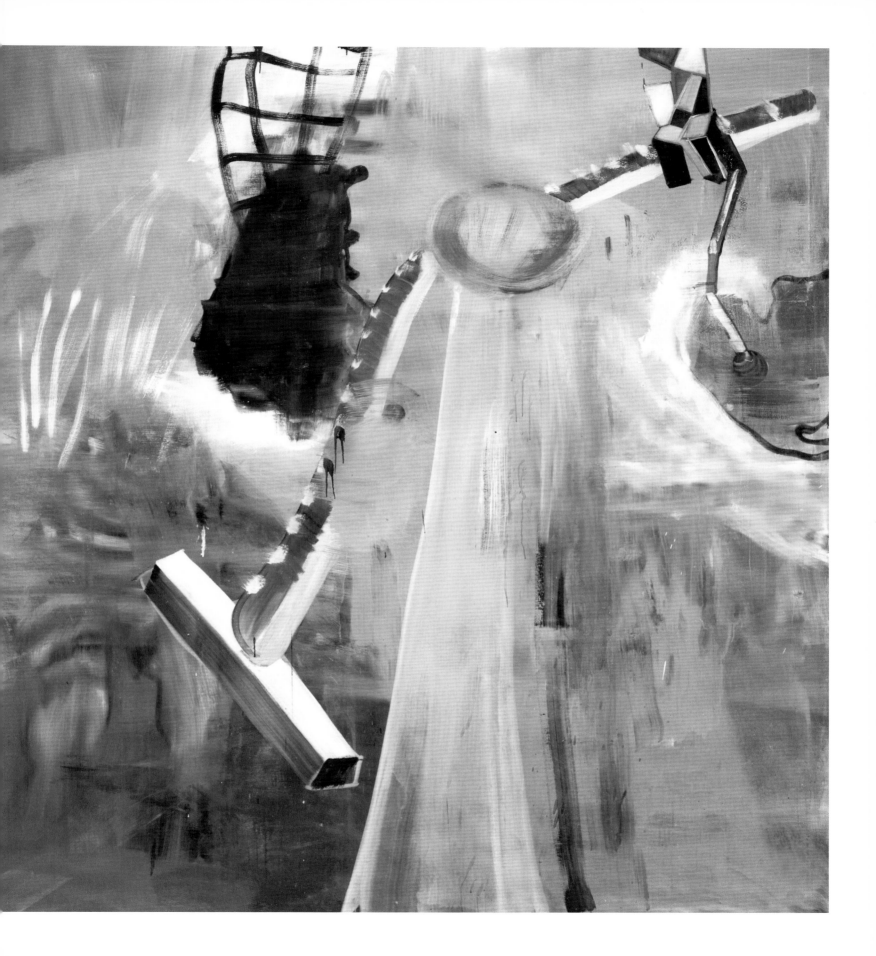

ALBERT OEHLEN
Mirage of Steel 2003
oil on canvas
280 x 340cm

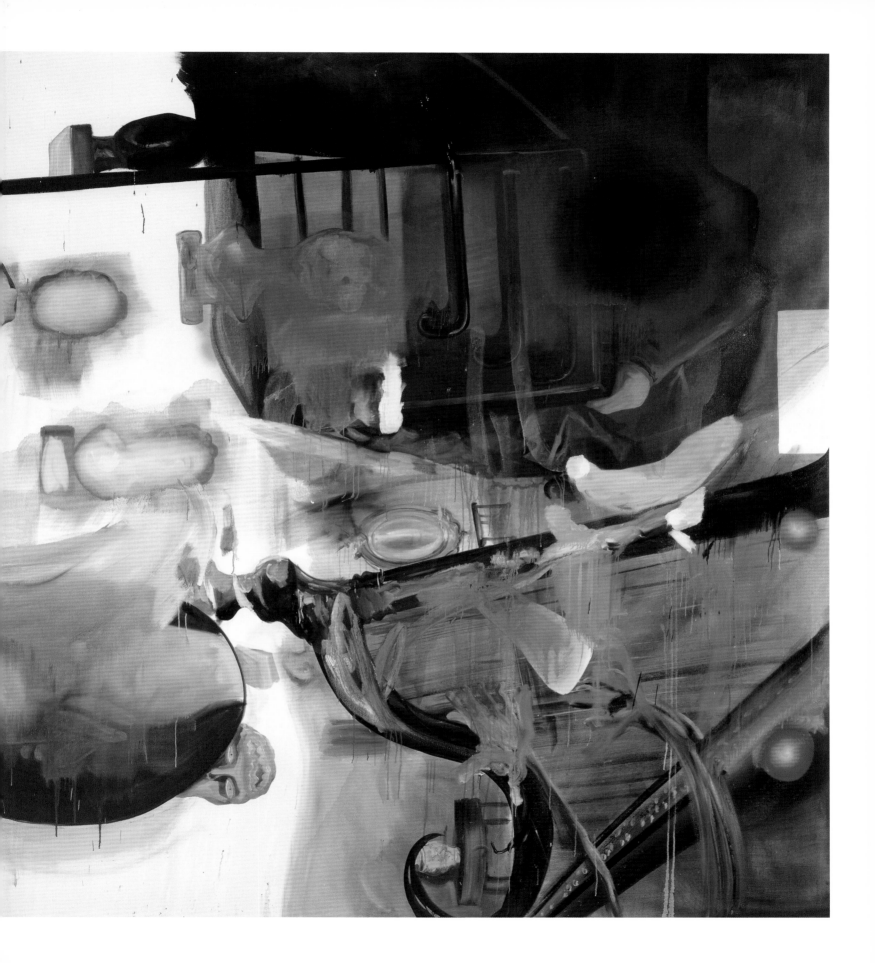

ALBERT OEHLEN
Untitled 1990
oil on canvas
213.5 x 162cm

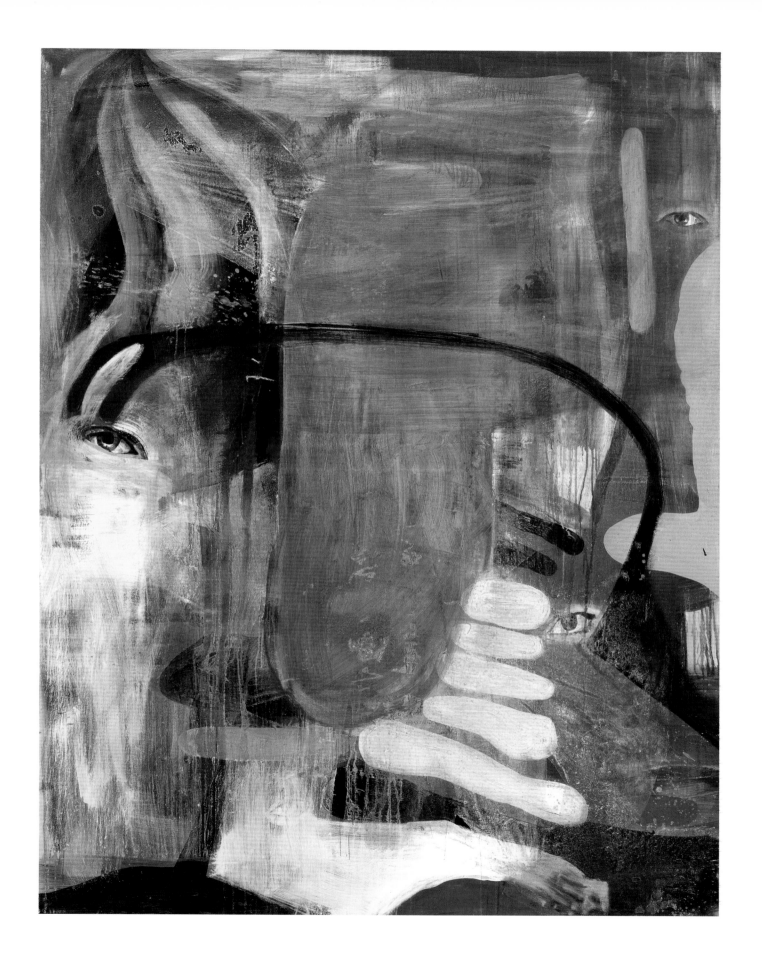

ALBERT OEHLEN
Untitled 1993
oil on canvas
200 x 200cm

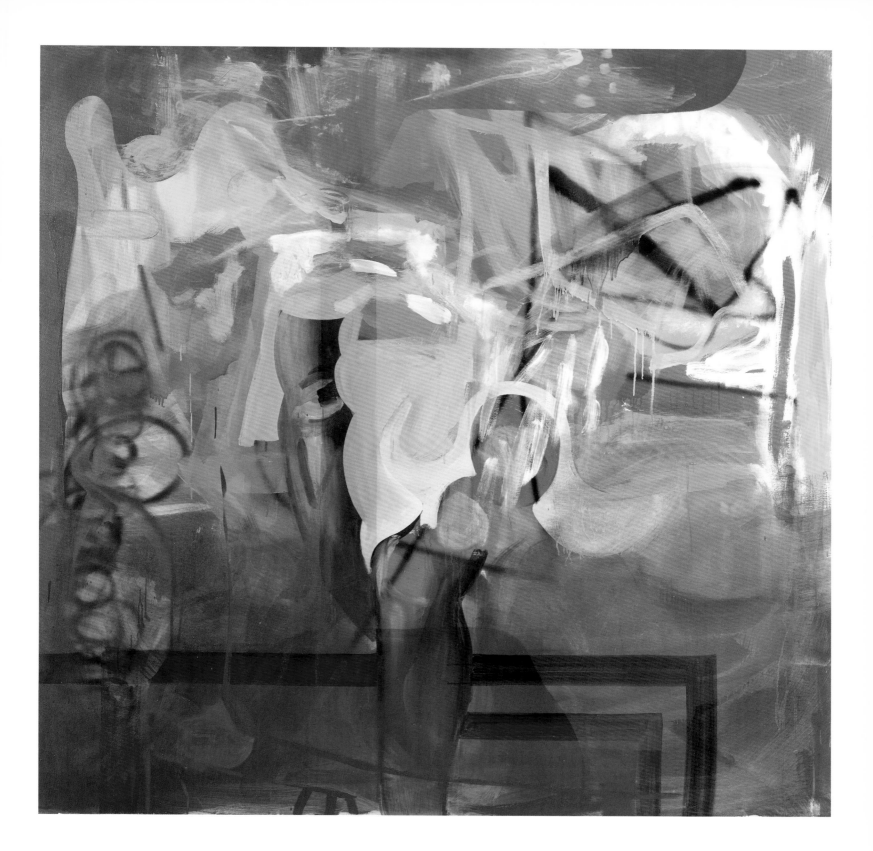

ALBERT OEHLEN
Untitled 1989
oil on canvas
200 x 200cm

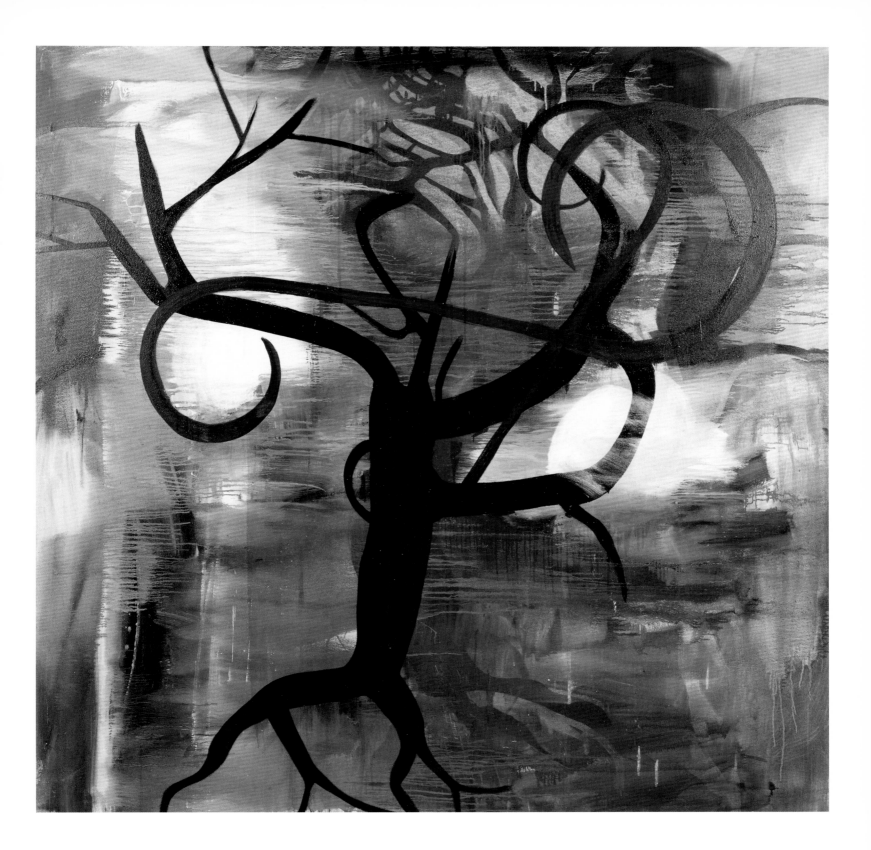

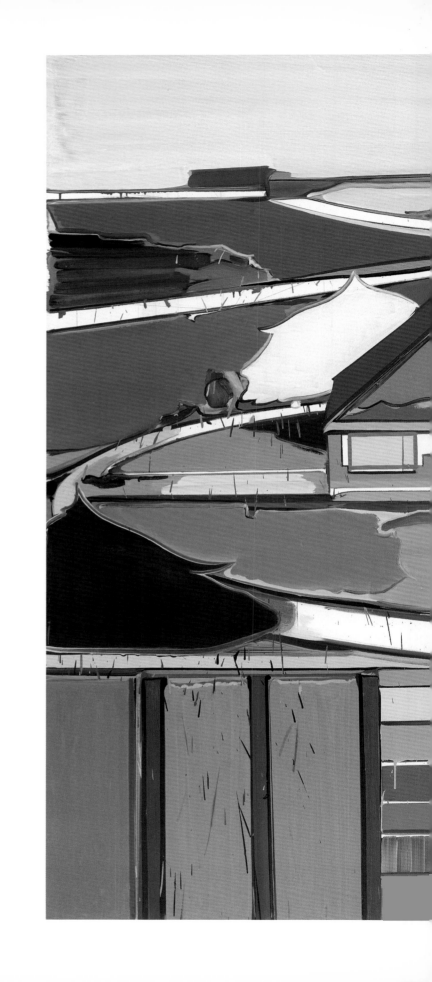

THOMAS SCHEIBITZ
Untitled 2002
oil on canvas
205 x 281cm

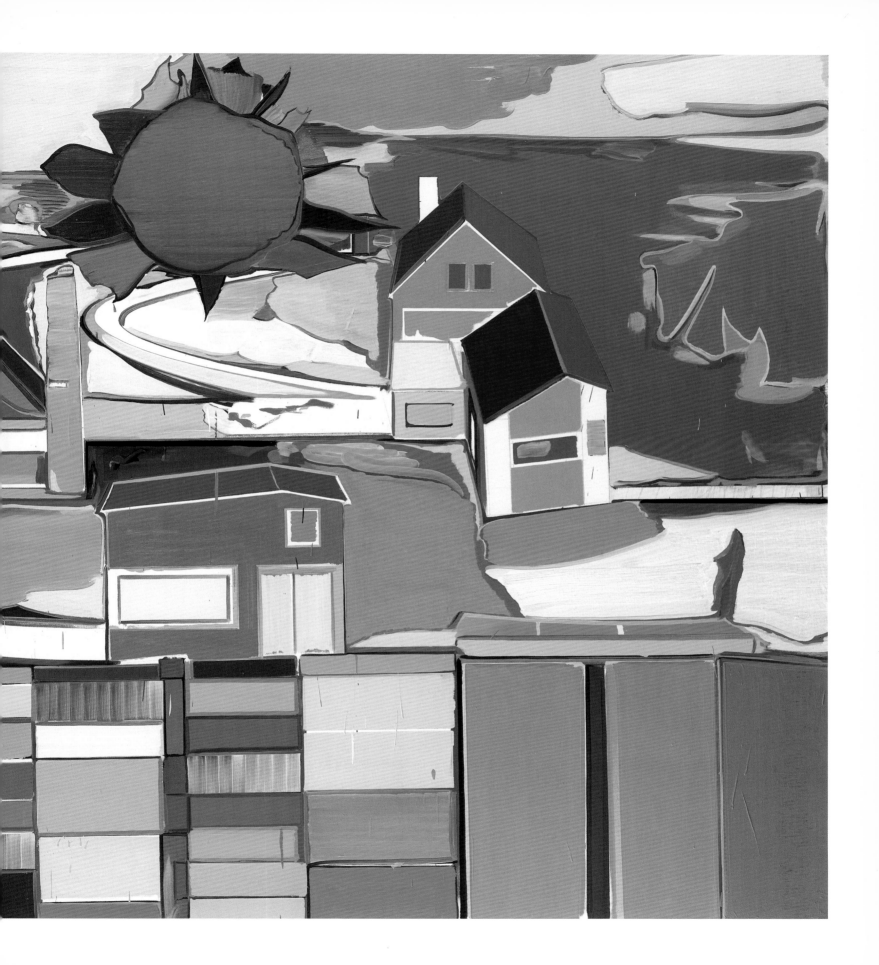

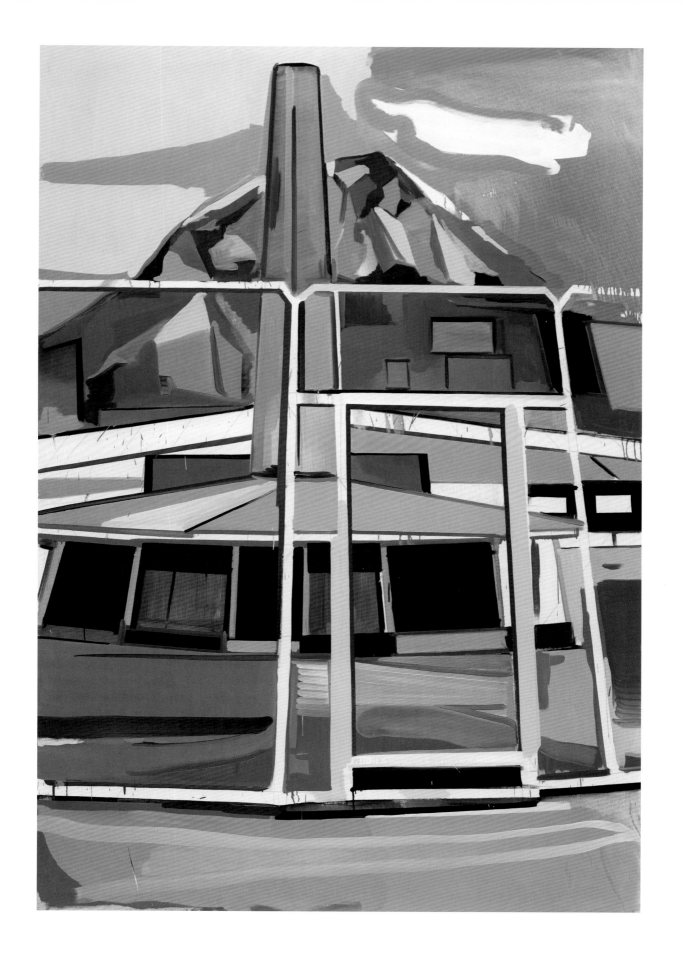

THOMAS SCHEIBITZ
Brillux 1999
oil on canvas
200 x 150cm

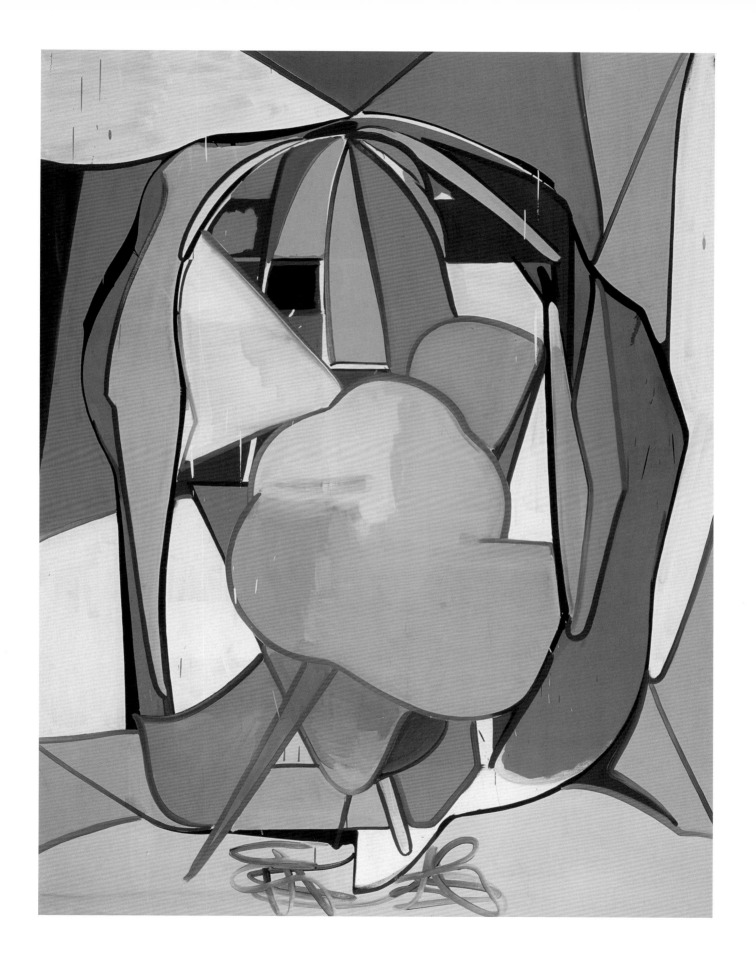

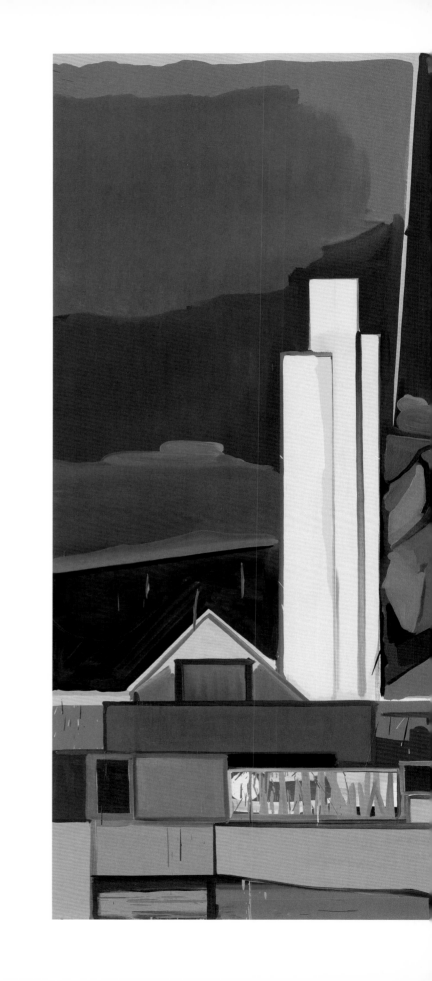

THOMAS SCHEIBITZ
Rosenweg 1999
oil on canvas
200 x 270cm

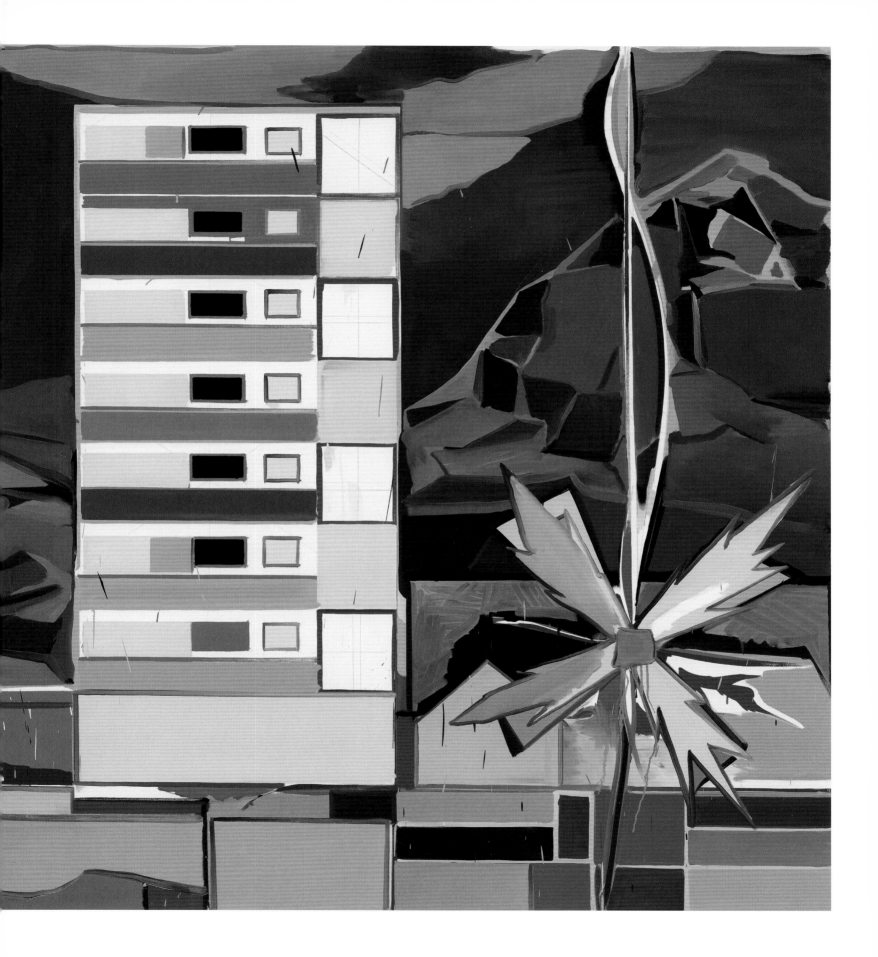

THOMAS SCHEIBITZ
Dubai 1999
oil on canvas
240 x 115cm

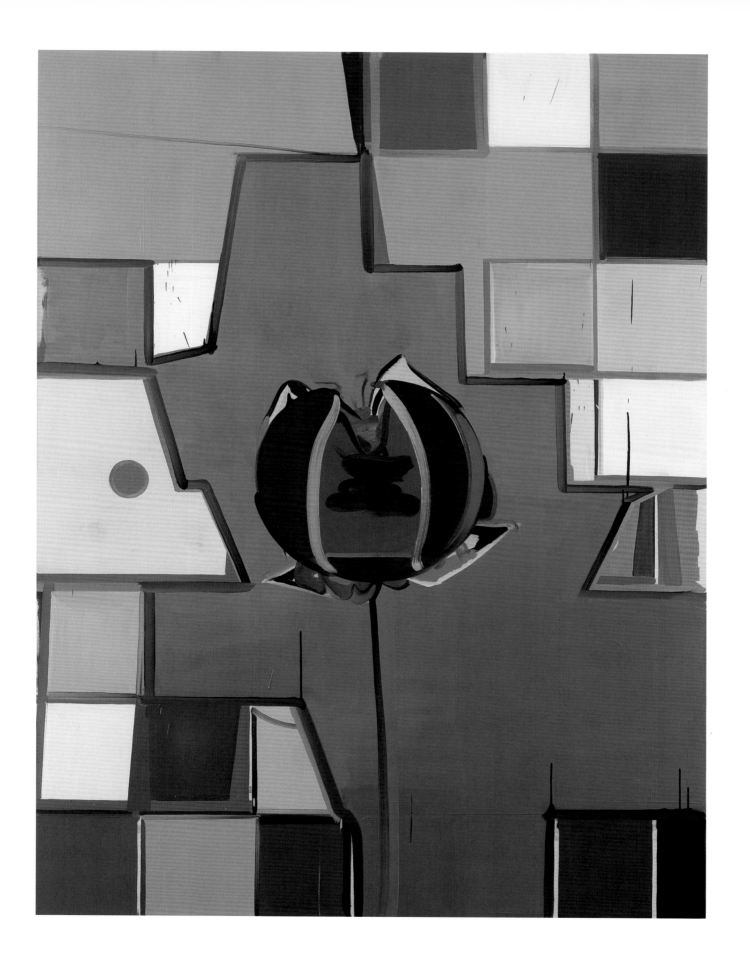

THOMAS SCHEIBITZ
Untitled No 242 1998
oil on canvas
142 x 106cm

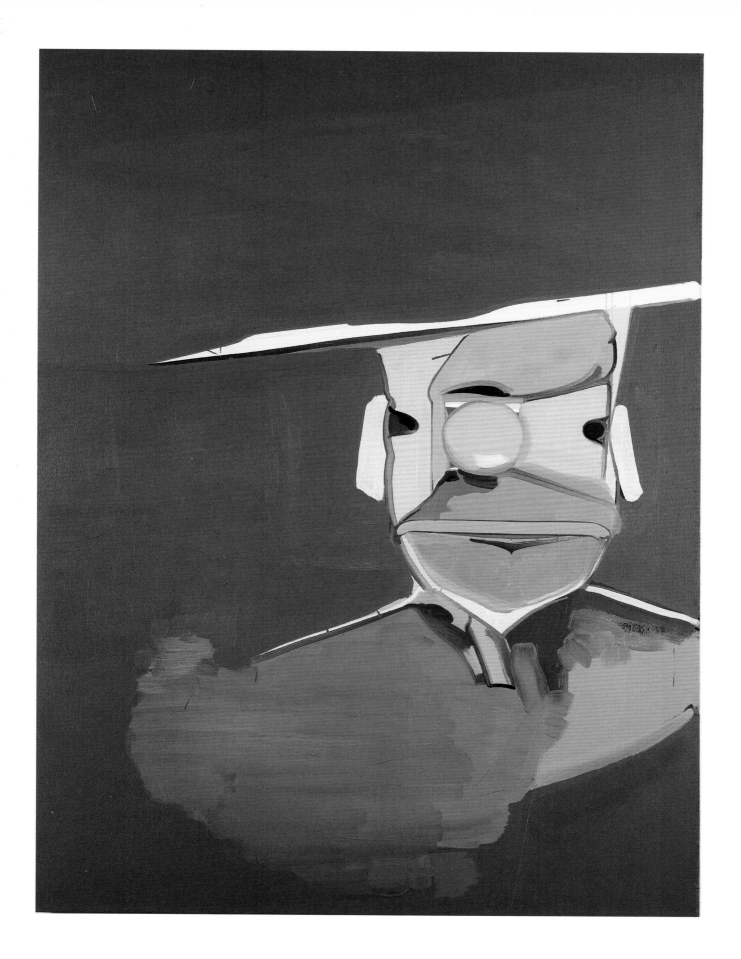

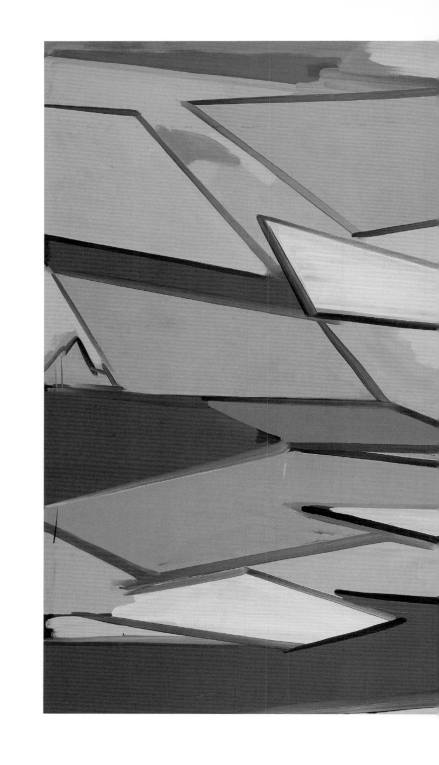

THOMAS SCHEIBITZ
Souvenir 1998
oil on canvas
150 x 270cm

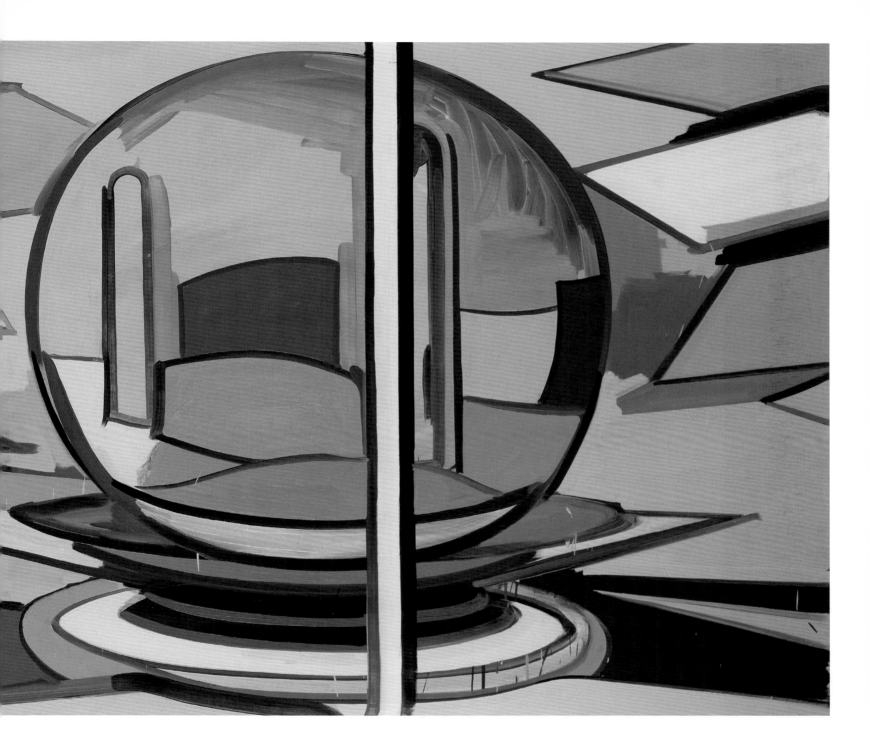

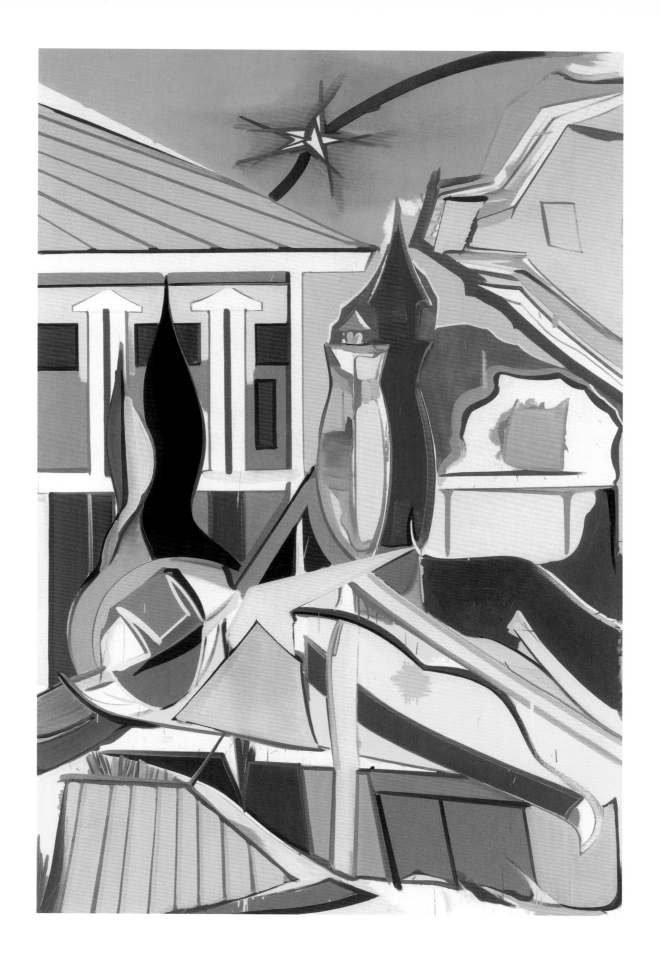

THOMAS SCHEIBITZ
Kromp 1997
oil on canvas
200 x 155cm

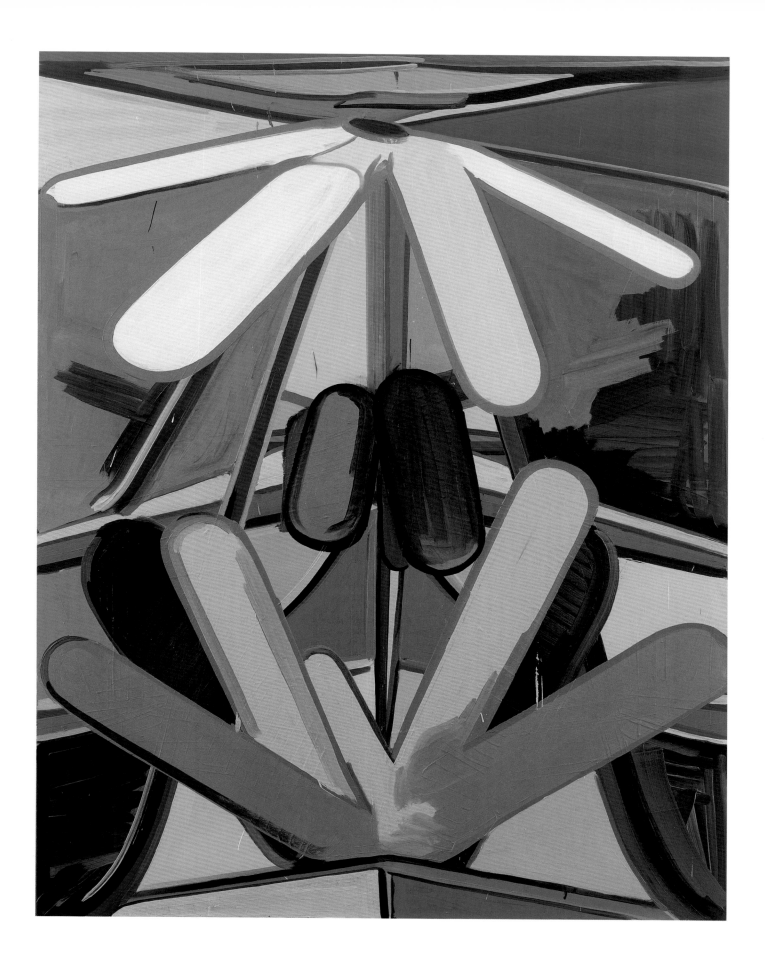

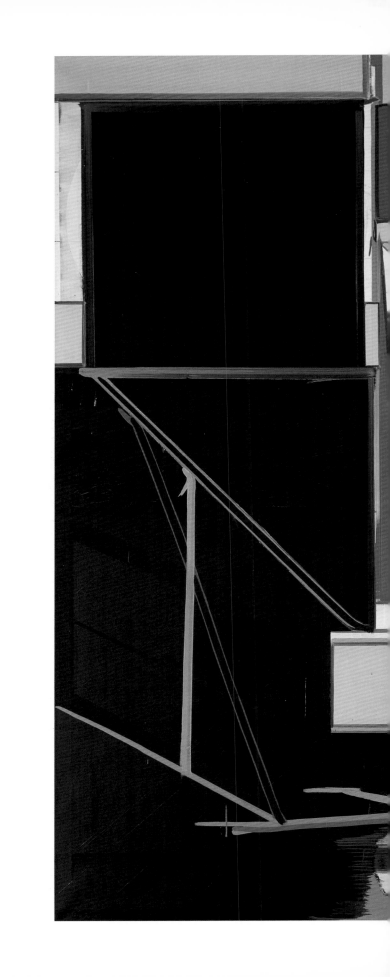

THOMAS SCHEIBITZ
Anlage 2000
oil on canvas
200 x 270cm

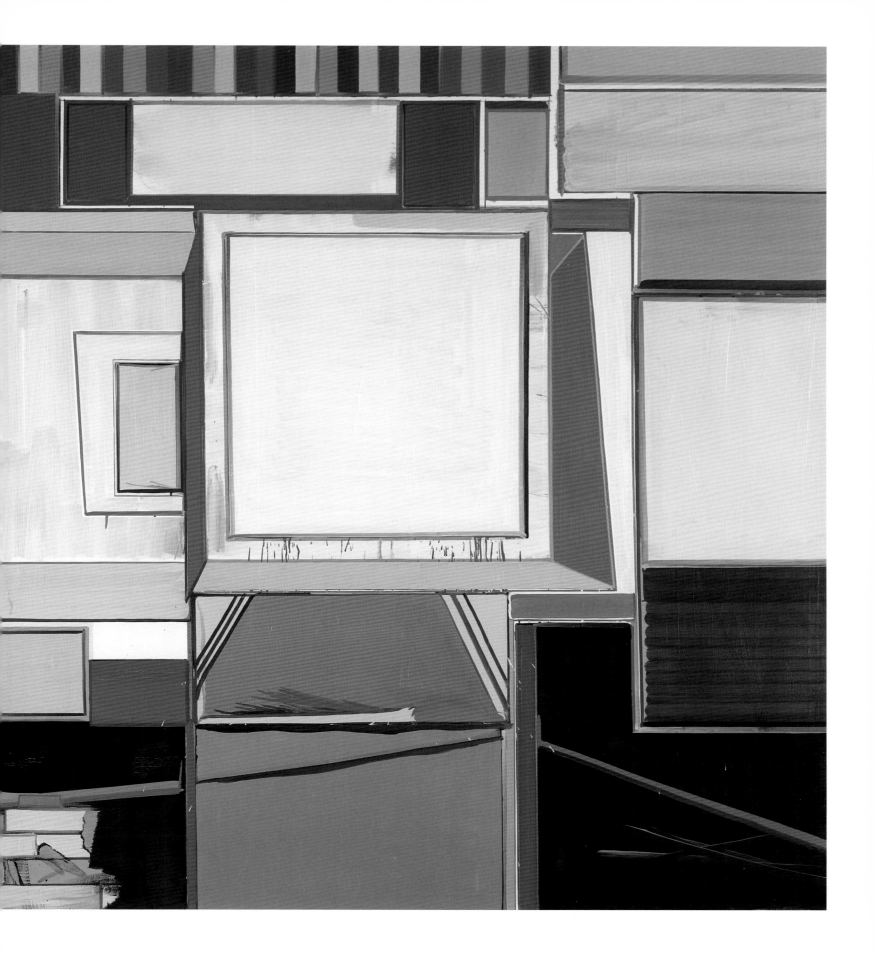

THOMAS SCHEIBITZ
Funny Game I 2000
oil and marker pen on canvas
200 x 150cm

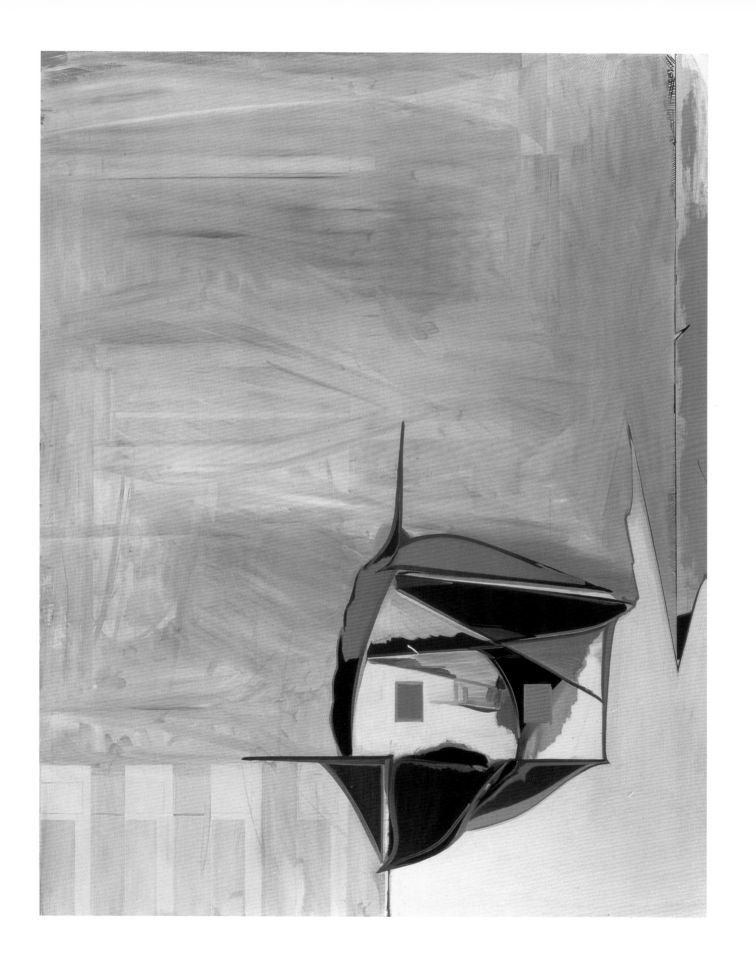

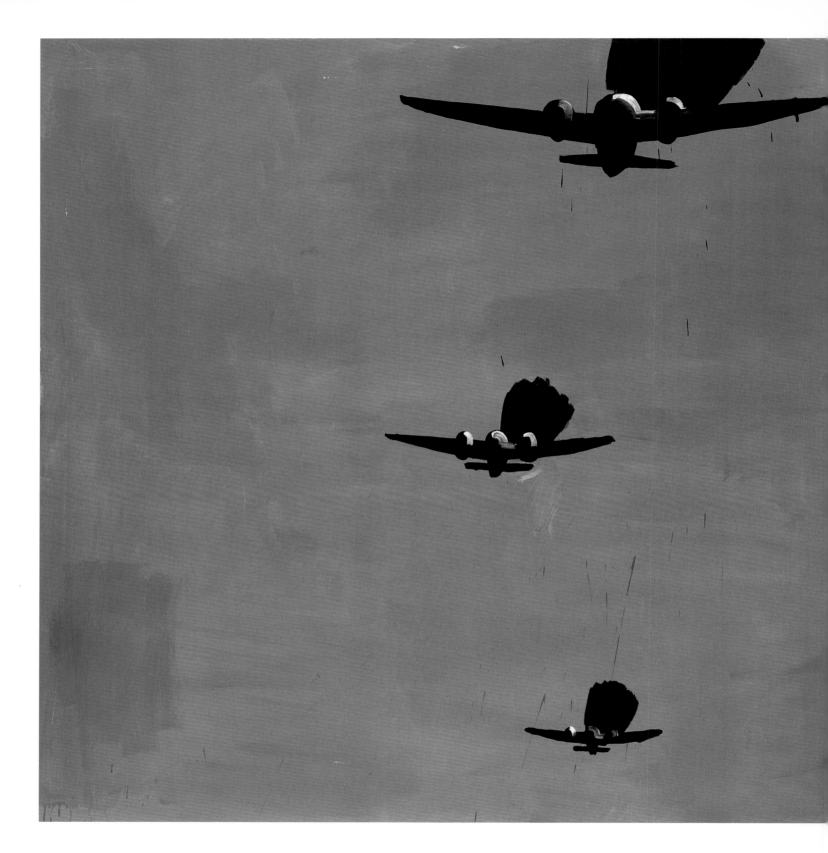

WILHELM SASNAL
Airplanes 2001
oil on canvas
150 x 300cm

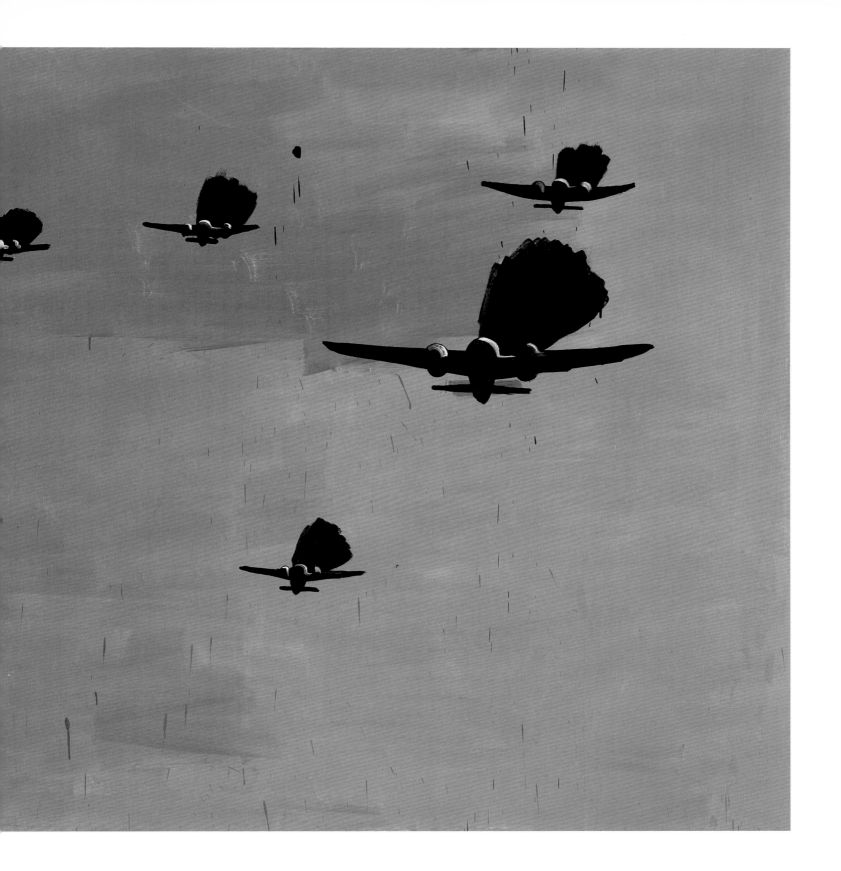

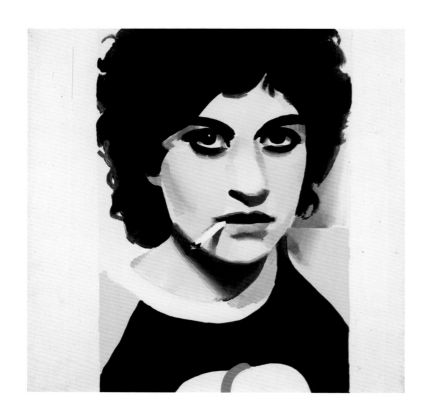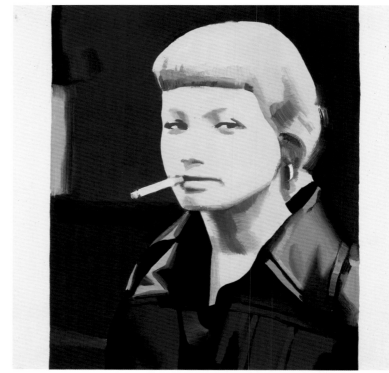

WILHELM SASNAL

above left:
Girl Smoking (Peaches) 2001
oil on canvas
33 x 33cm

above right:
Girl Smoking (Dominika) 2001
oil on canvas
33 x 33cm

opposite:
Girl Smoking (Anka) 2001
oil on canvas
50 x 45cm

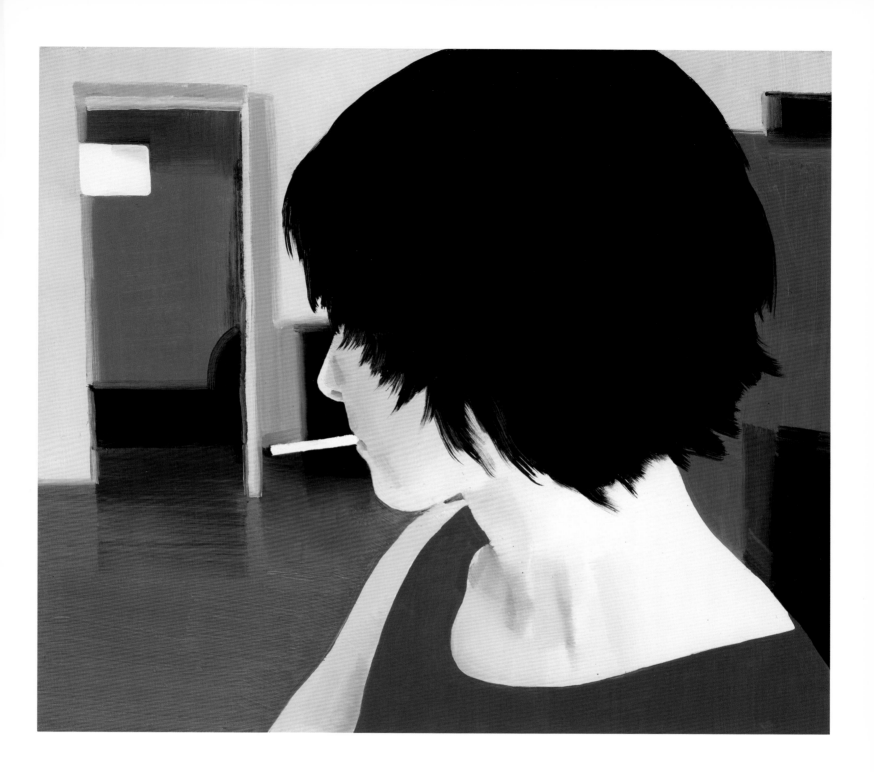

WILHELM SASNAL
Factory 2000
oil on canvas
101 x 101cm

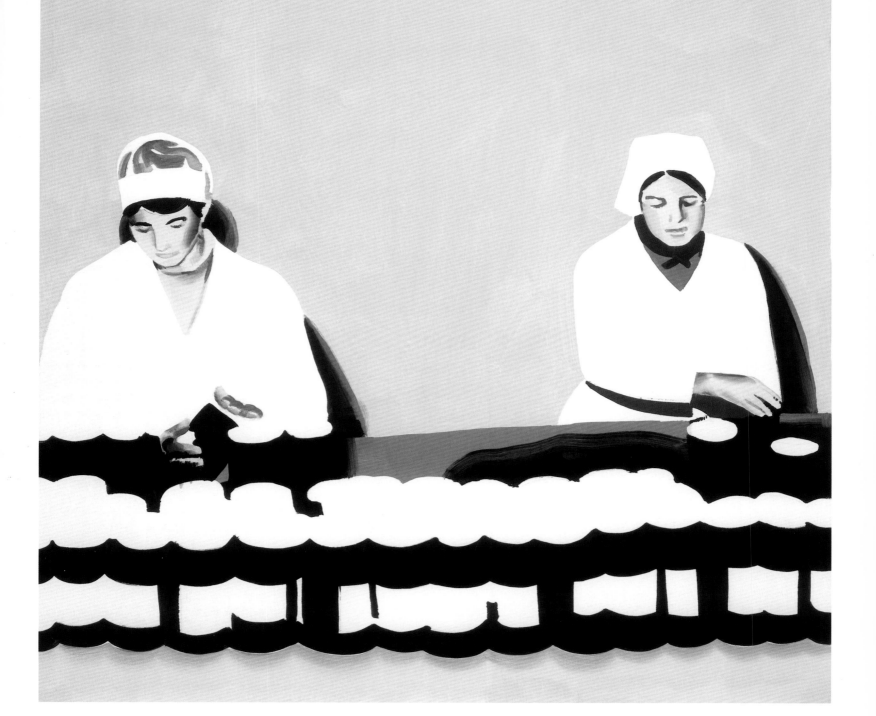

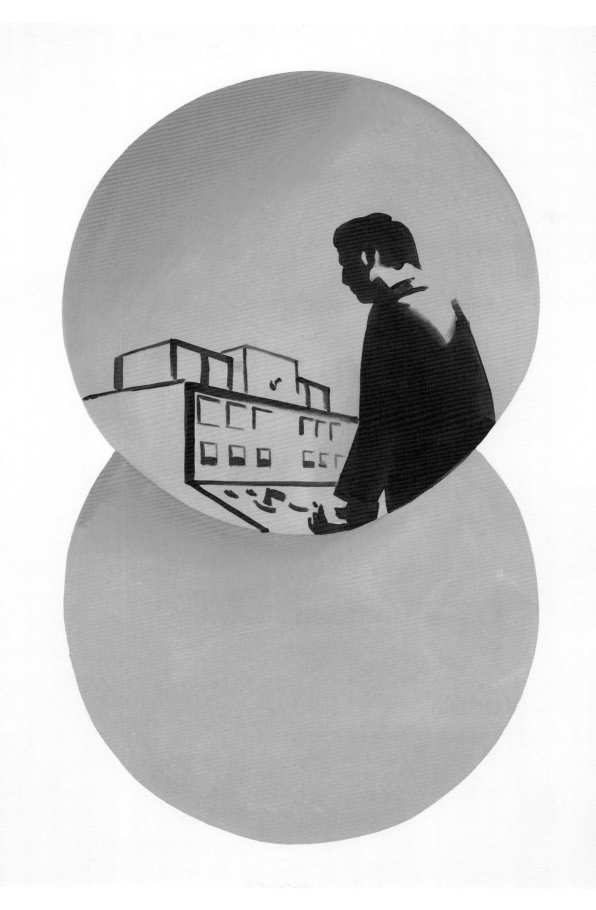

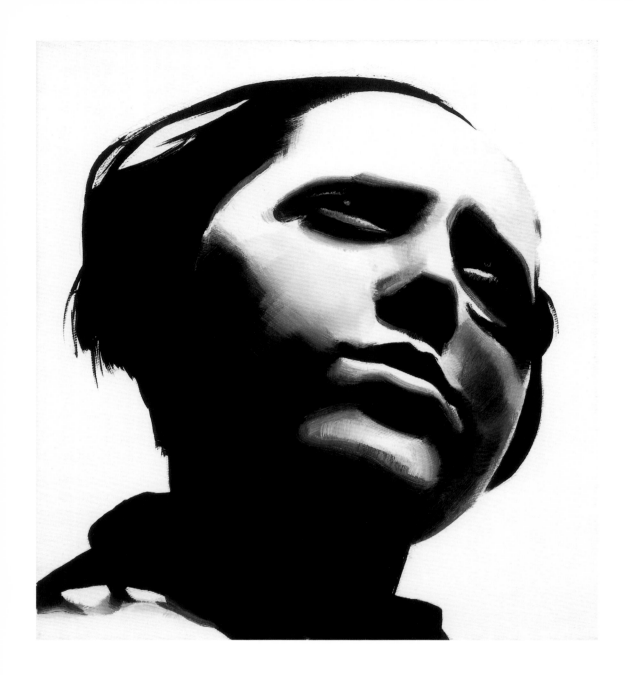

WILHELM SASNAL

above:
Portrait after Rodchenko, Lady 2002
oil on canvas
30 x 30cm

opposite:
Terrorist Equipment 2000
oil on canvas
63 x 80cm

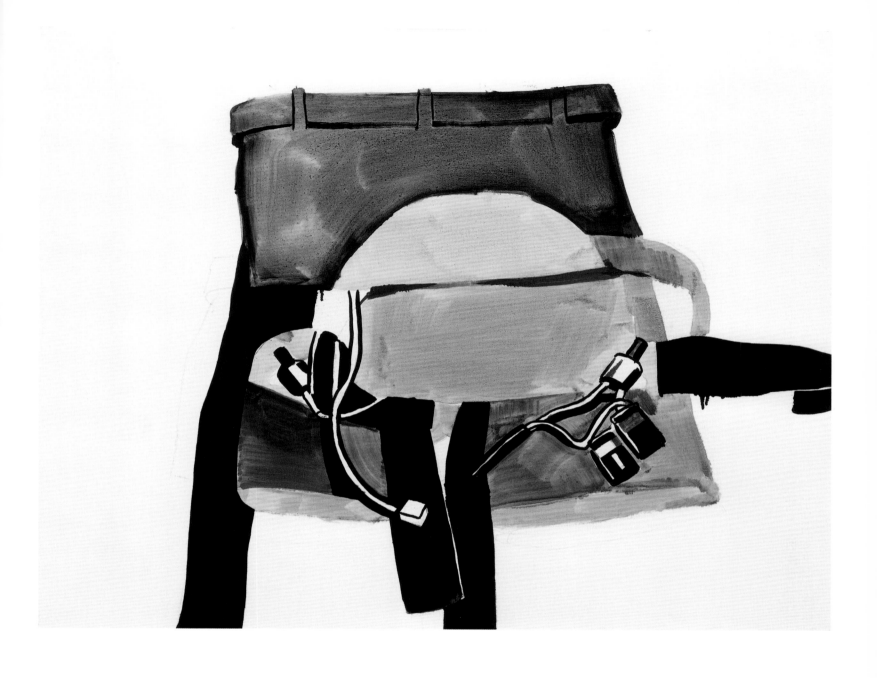

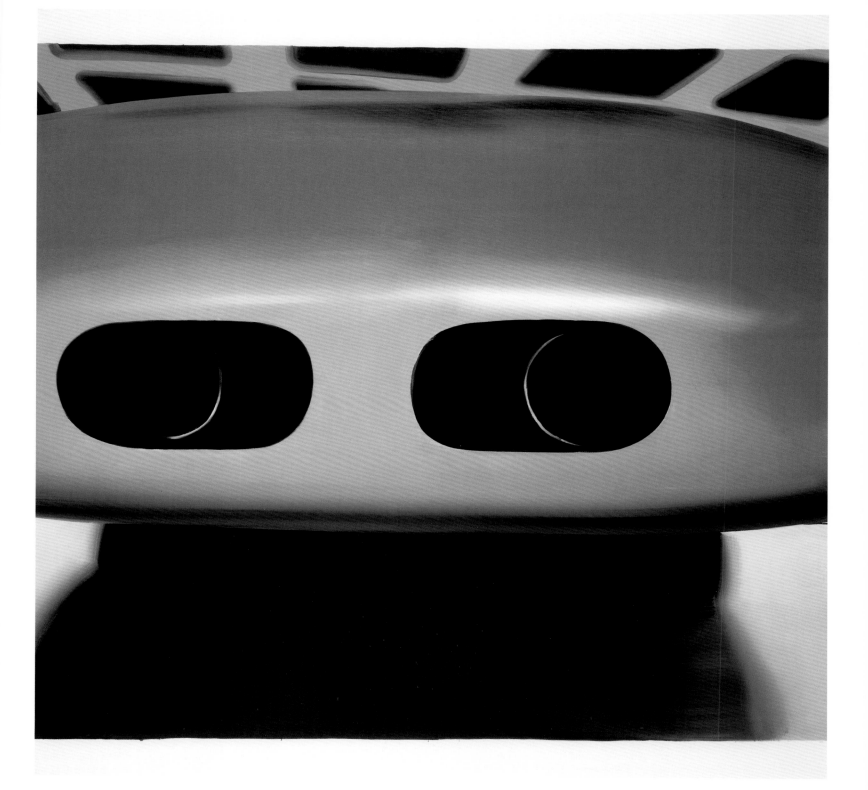

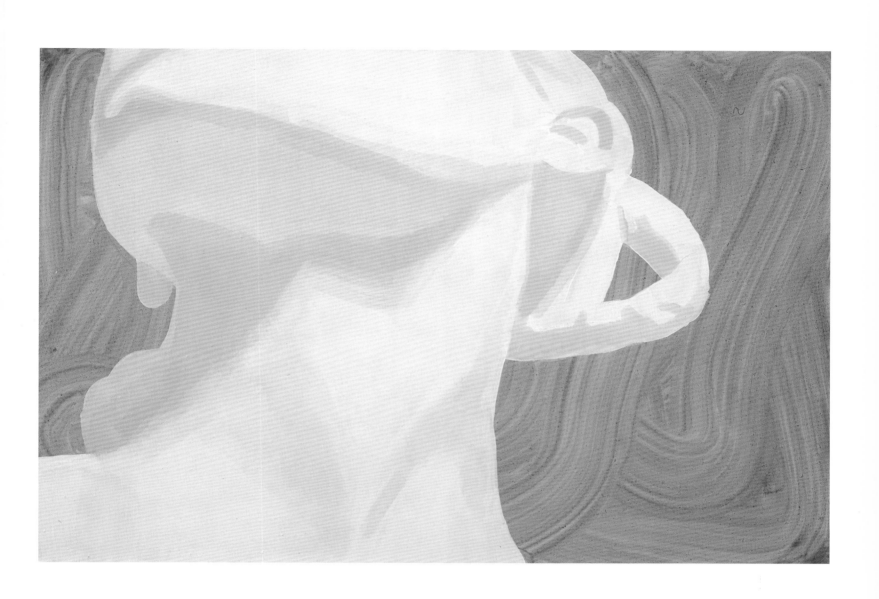

WILHELM SASNAL
Gym Lesson 2000
oil on canvas
150 x 150cm

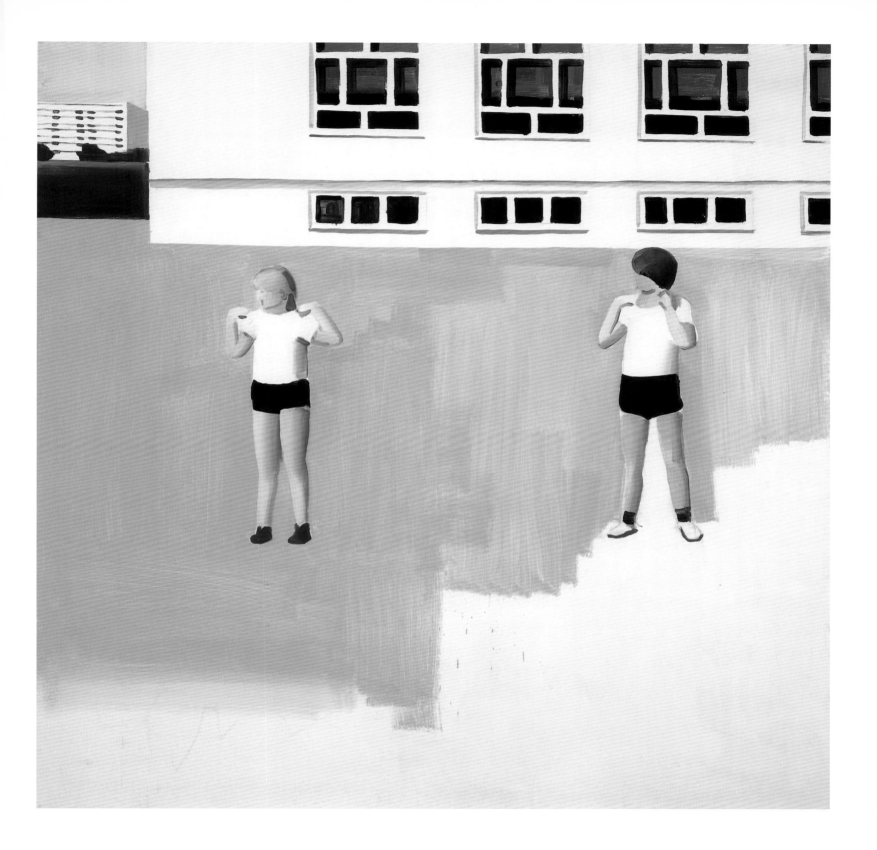

WILHELM SASNAL
Soldiers 2000
oil on canvas
175 x 175cm

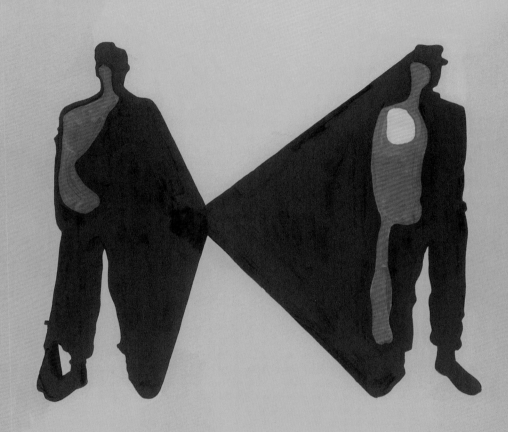

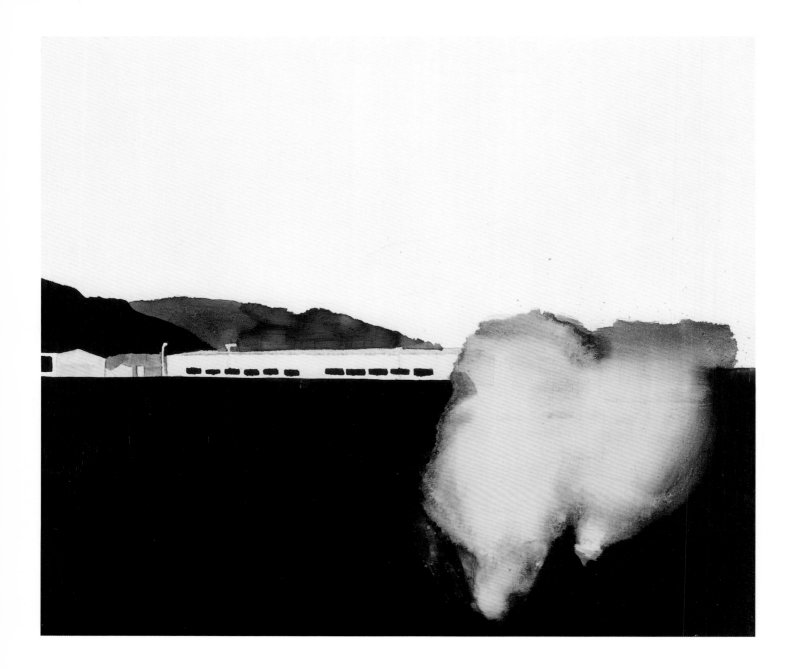

WILHELM SASNAL

above:
Landscape 2001
oil on canvas
36 x 40cm

opposite:
Arms Raised 2001
oil on canvas
33 x 36cm

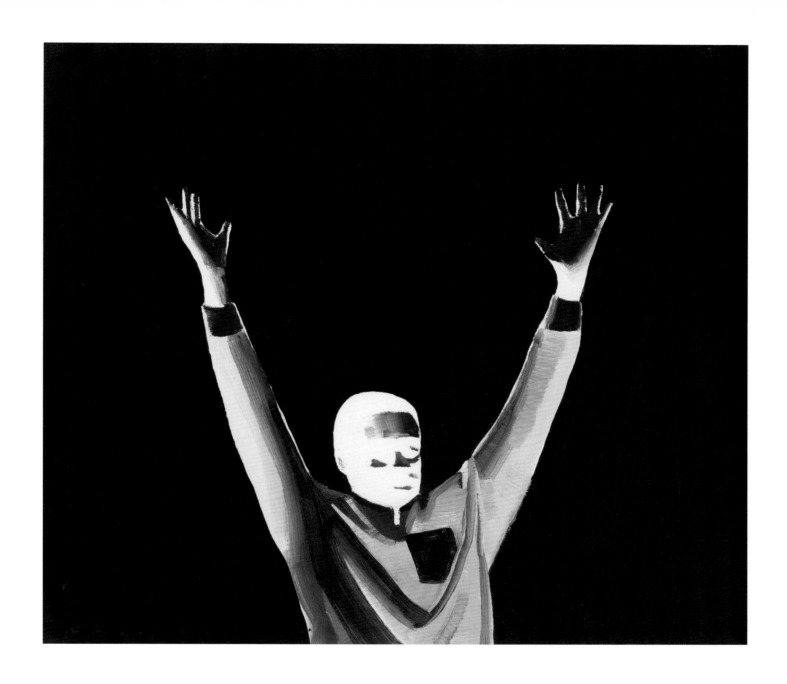

WILHELM SASNAL
Resort 1999
oil on canvas
88.9 x 88.9cm

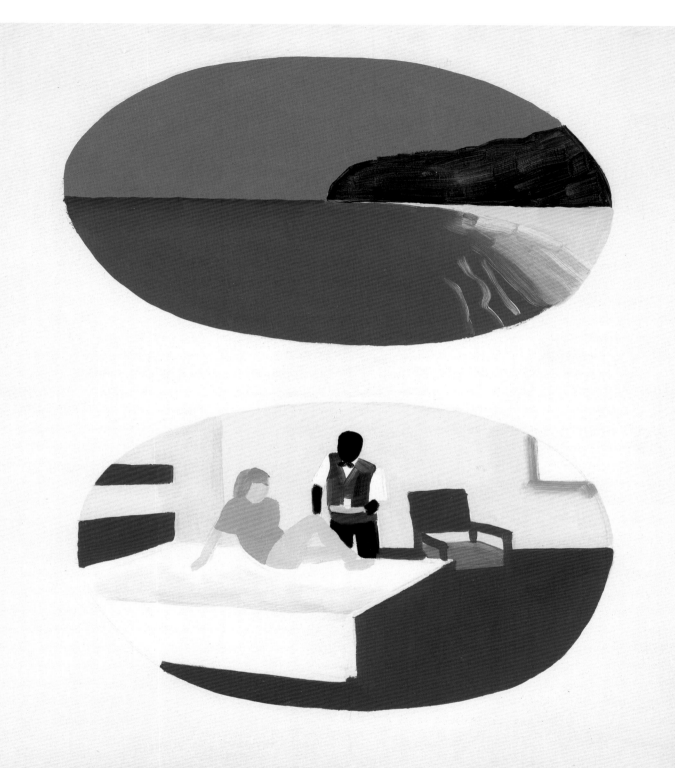

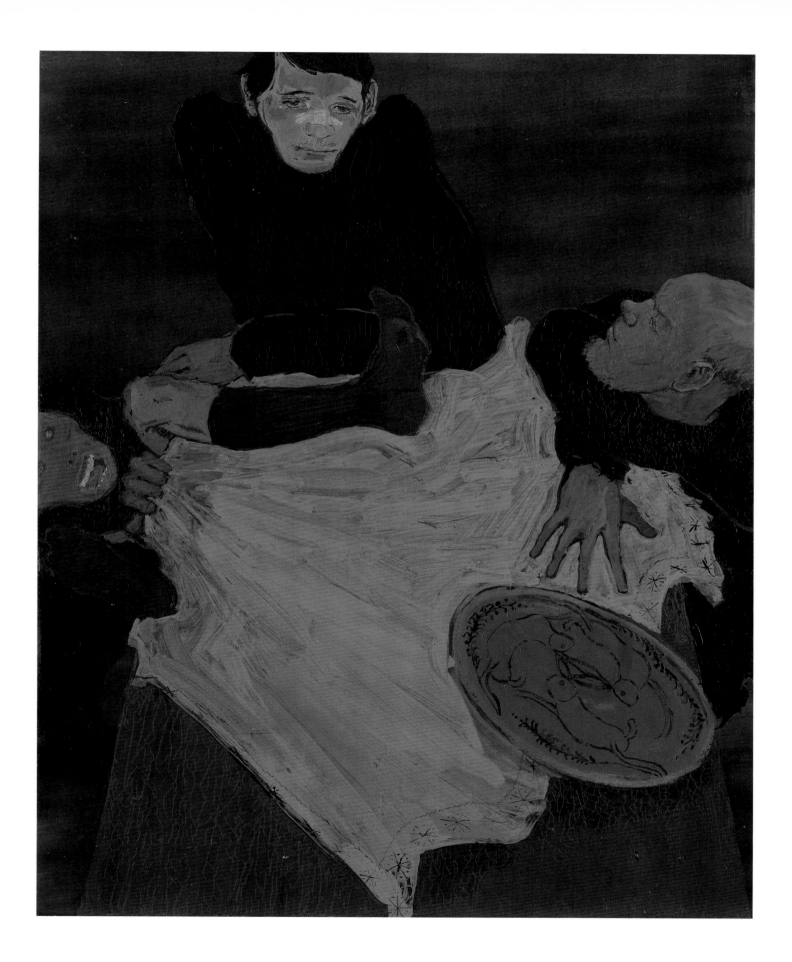

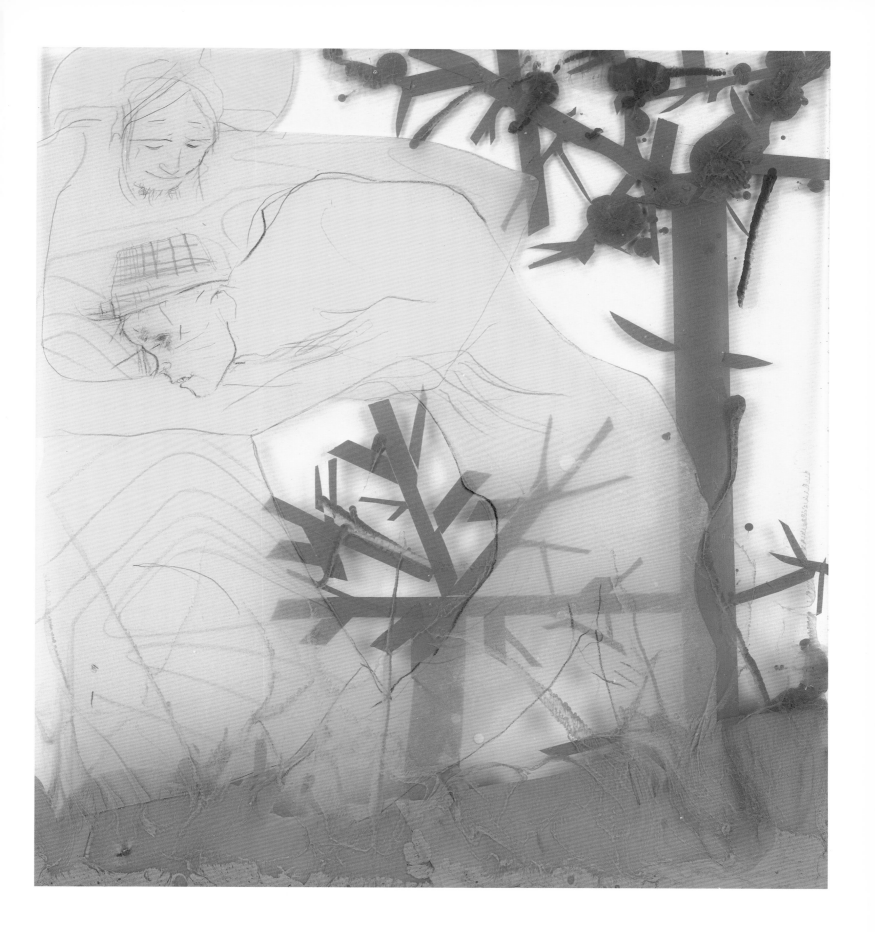

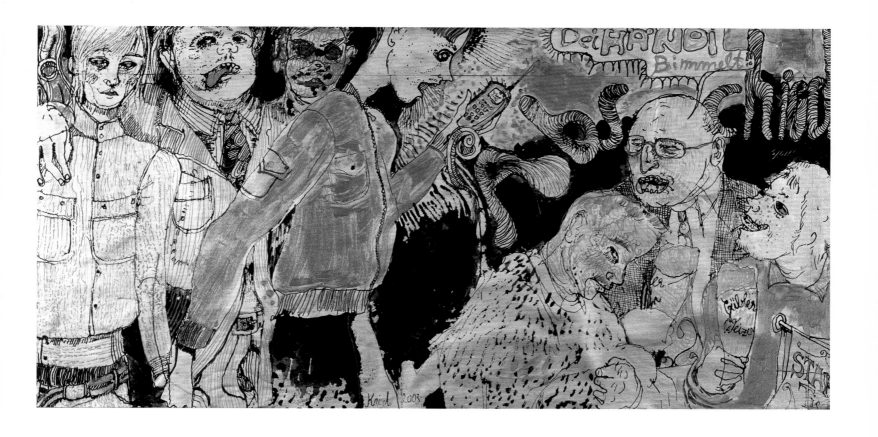

KAI ALTHOFF
Untitled 1997
pen, pencil and tape on board
186 x 100cm

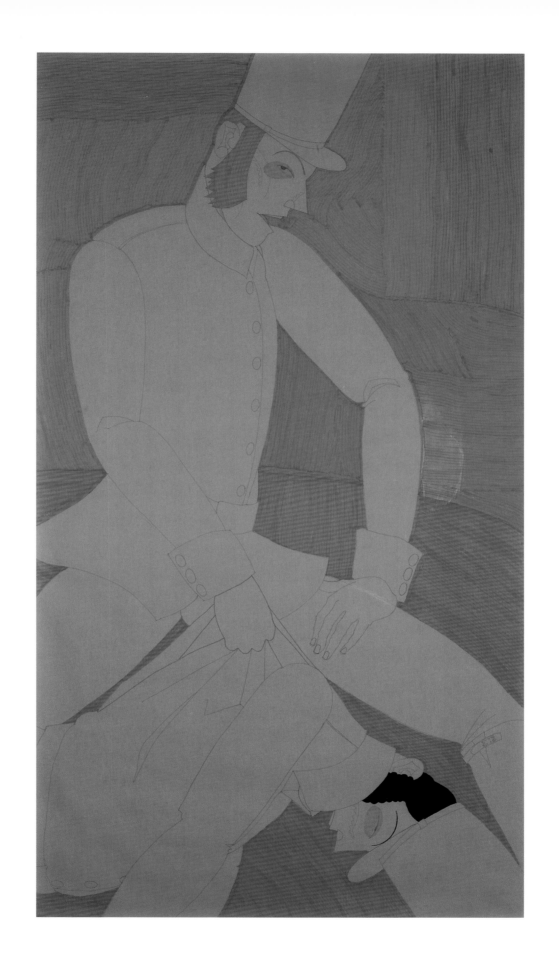

KAI ALTHOFF
Untitled 2000
lacquer, paper, watercolour and varnish on canvas
50 x 50cm

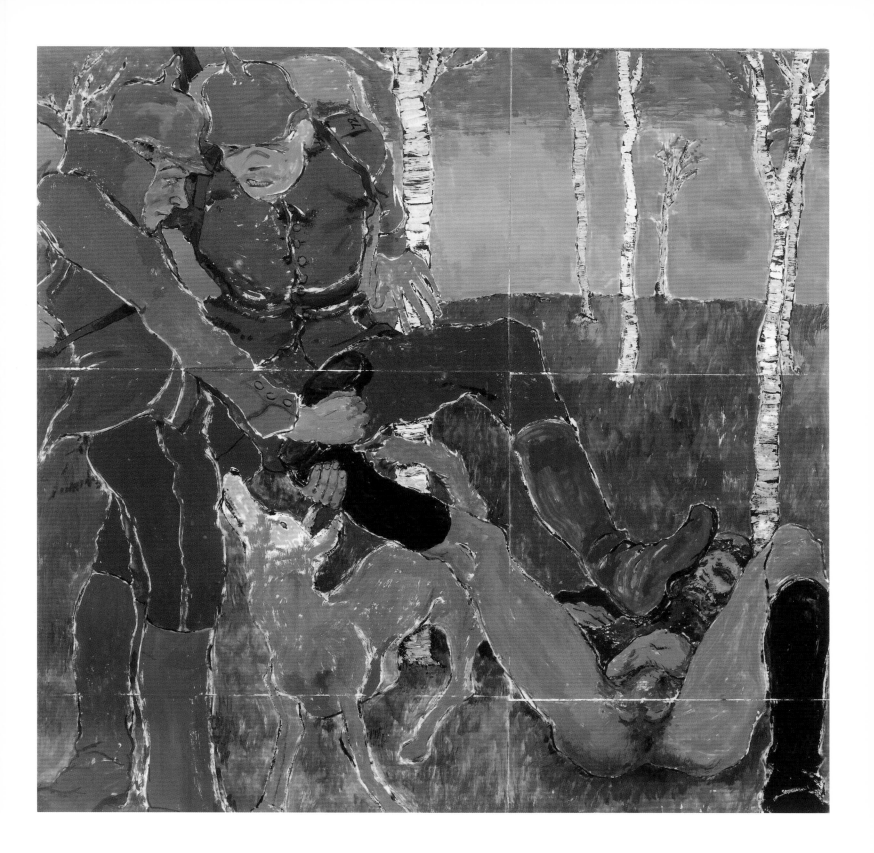

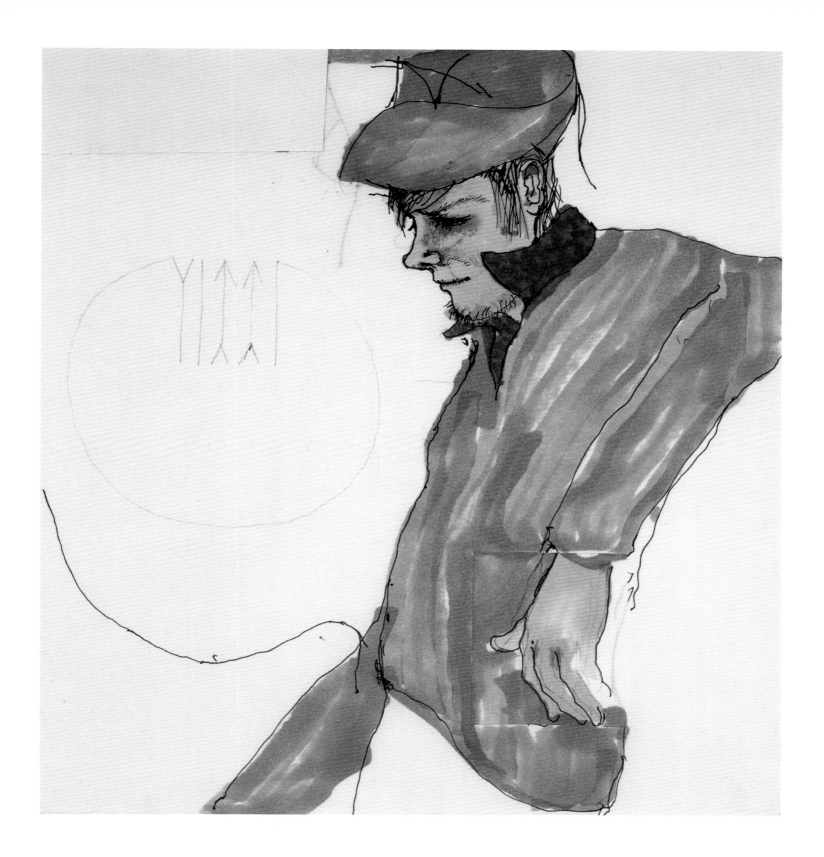

KAI ALTHOFF
Winter 2002
aluminium foil, boat lacquer, ink, watercolour, metallic paint and varnish on canvas
60 x 40cm

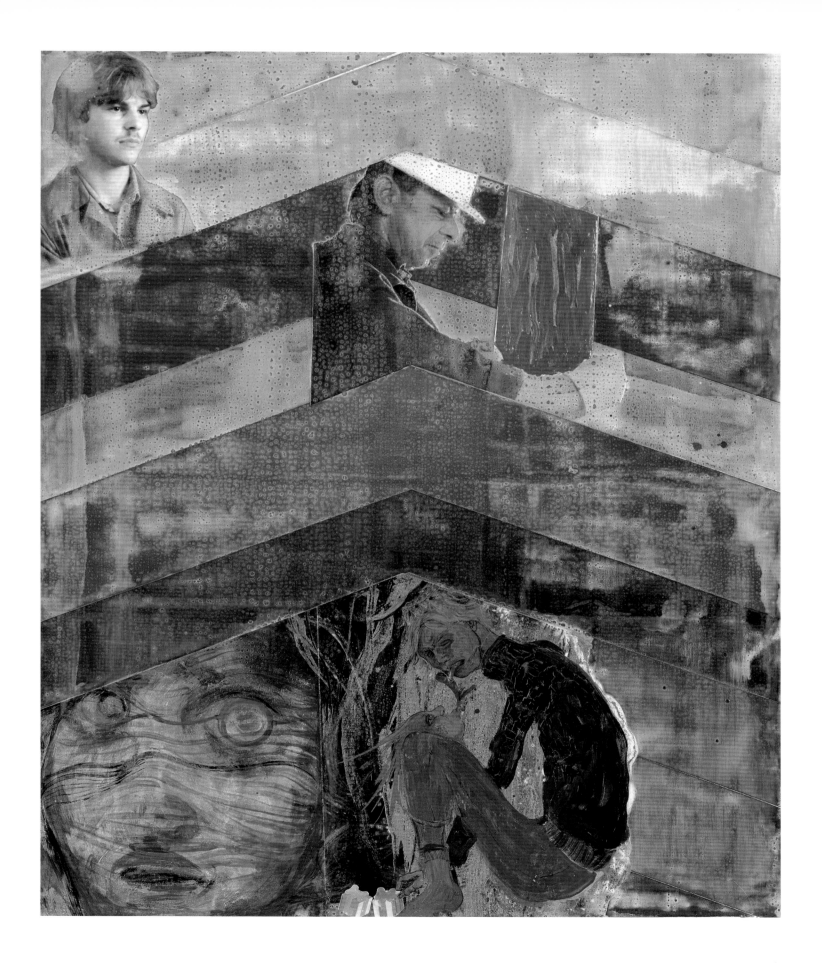

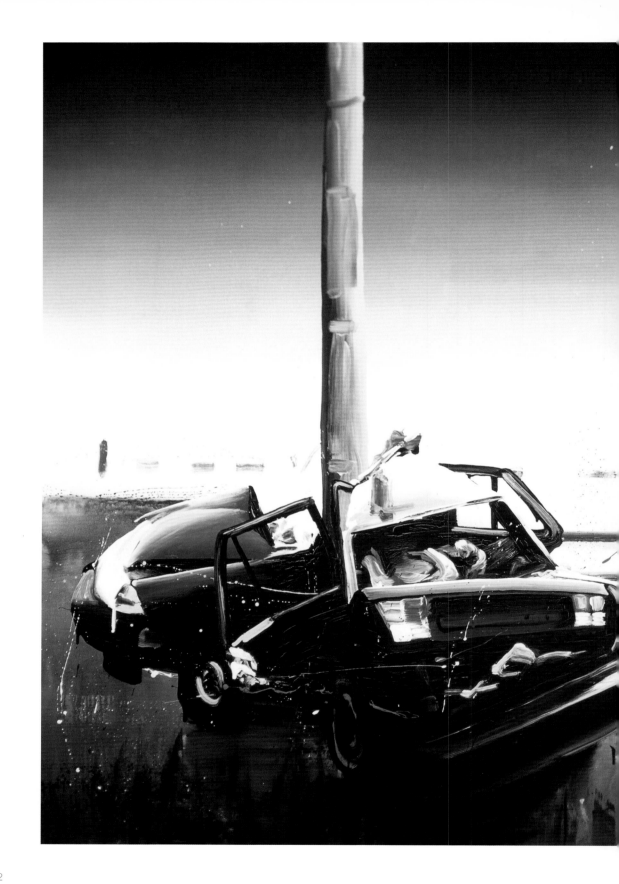

DIRK SKREBER
It Rocks Us So Hard - Ho, Ho, Ho, 2.0 2002
oil on canvas
160 x 280cm

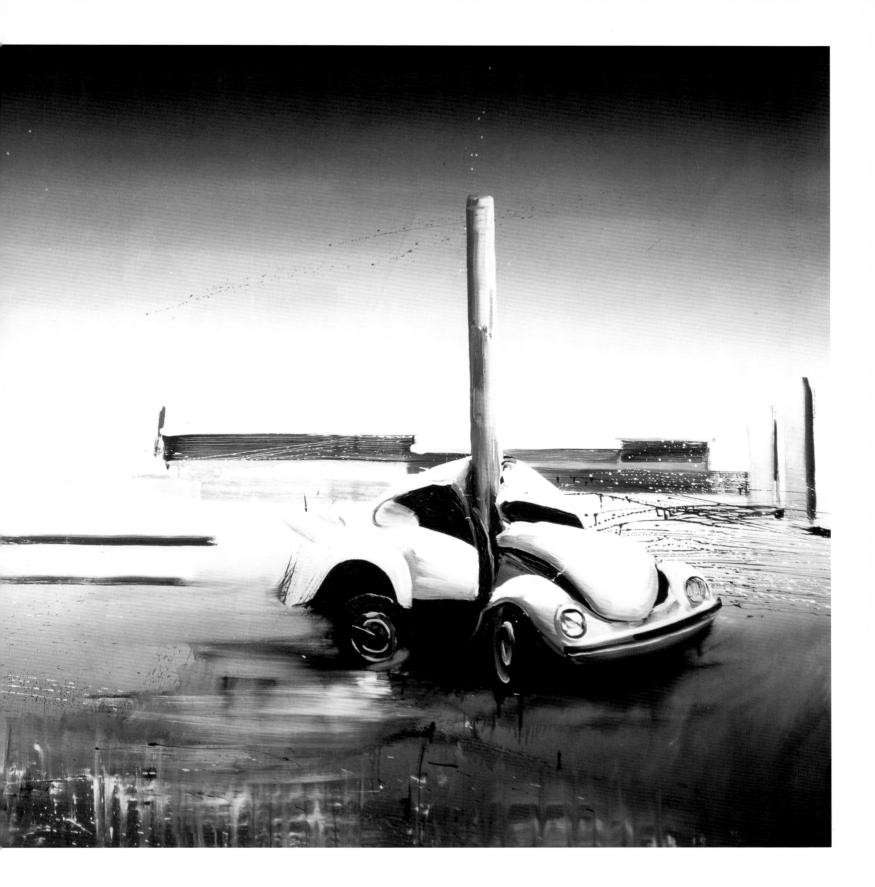

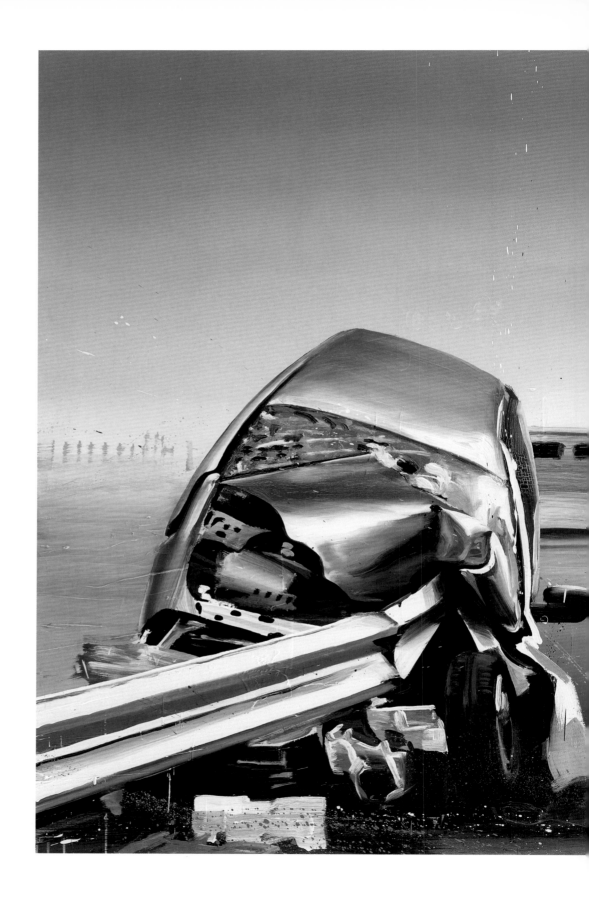

DIRK SKREBER
It Rocks Us So Hard - Ho, Ho, Ho, 3.0 2002
oil on canvas
170 x 290cm

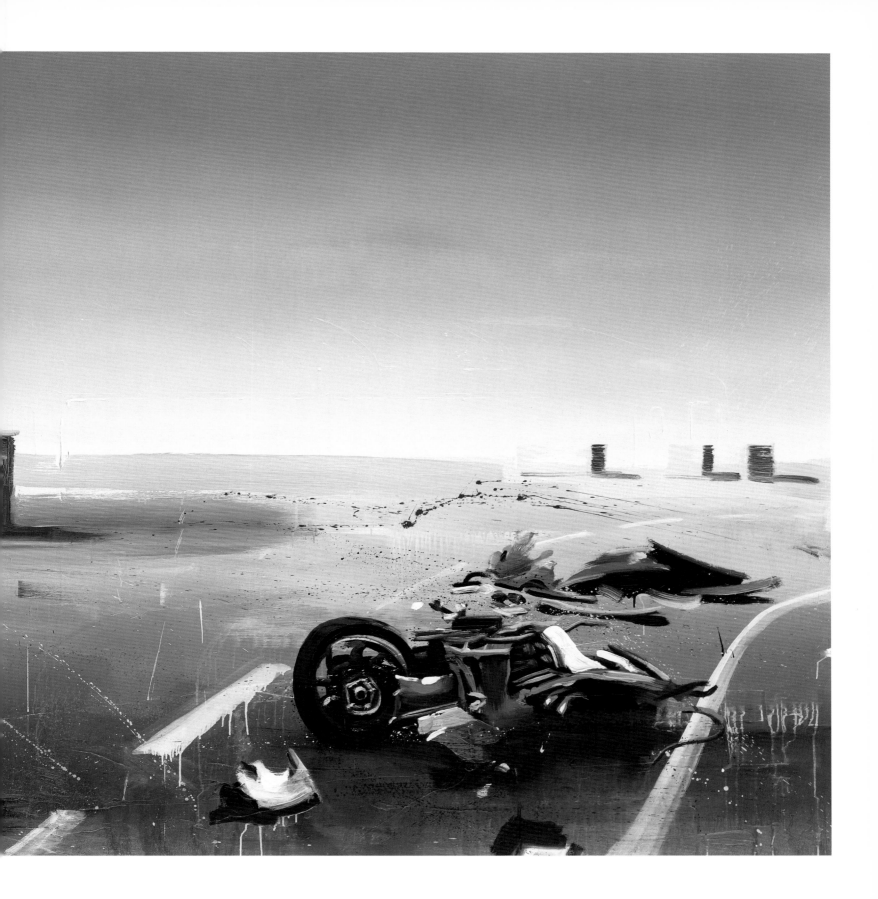

DIRK SKREBER
Untitled 2003
oil on canvas
300 x 170cm

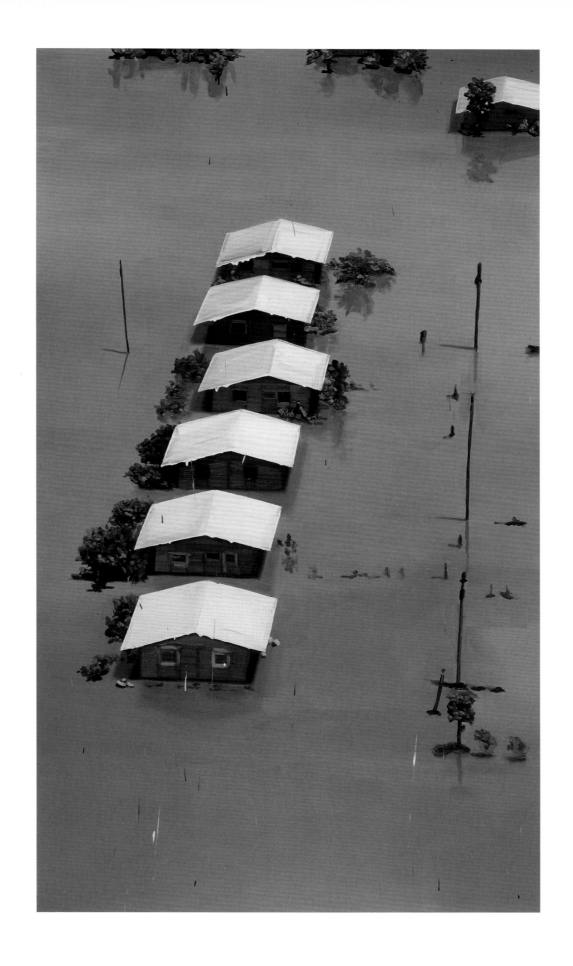

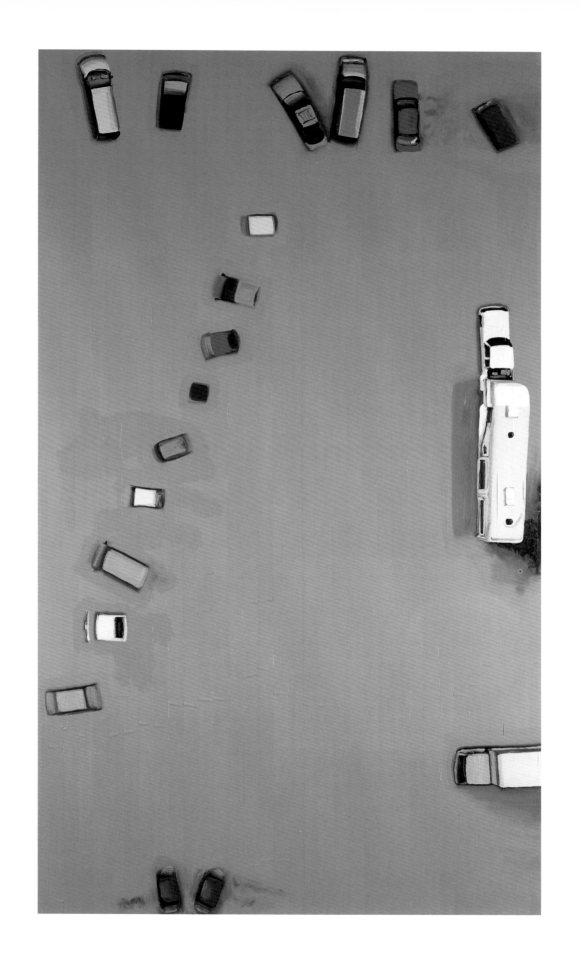

DIRK SKREBER
Untitled 1999
oil, tape and foam rubber on canvas
180 x 200cm

DIRK SKREBER
Untitled 2000
oil on canvas
280 x 420cm

DIRK SKREBER
Untitled 1999
oil, foil tape and foam rubber on canvas
150 x 250cm

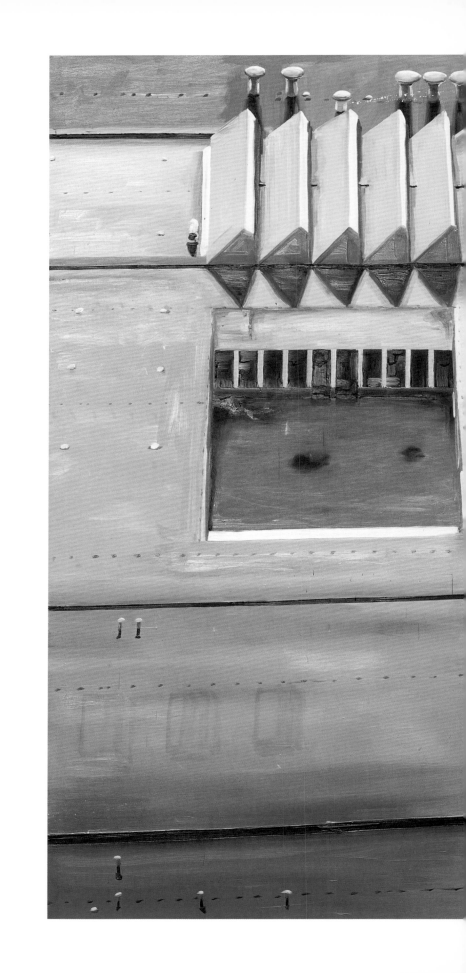

DIRK SKREBER
Untitled 2003
oil on canvas
279.4 x 400cm

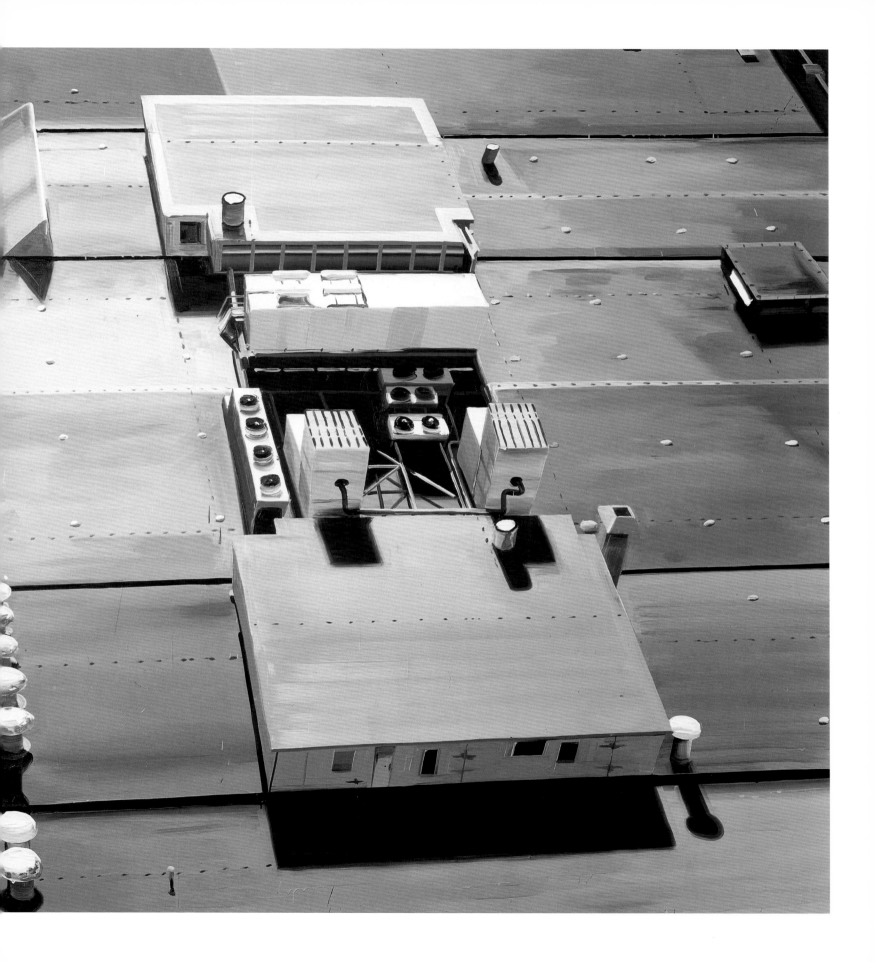

DIRK SKREBER
Untitled 1990
oil on canvas
205 x 100cm

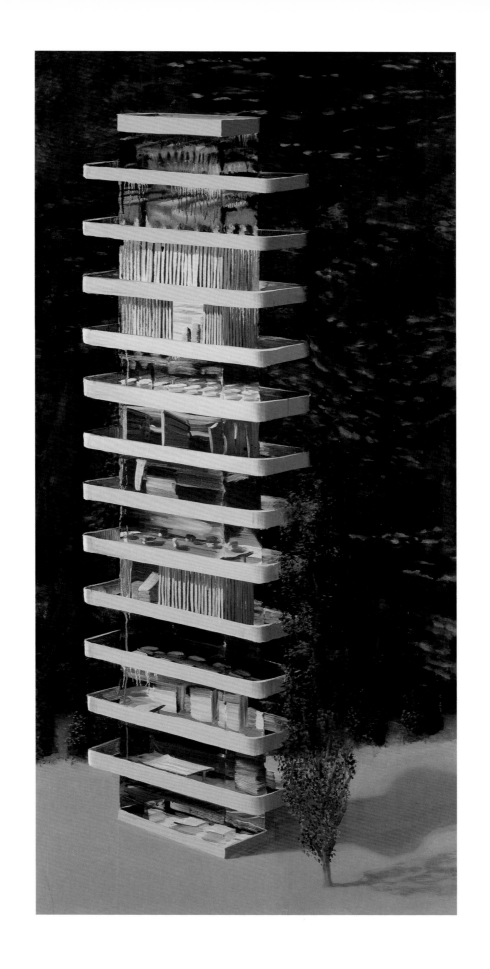

DIRK SKREBER
Untitled 1999
oil on canvas
190 x 165cm

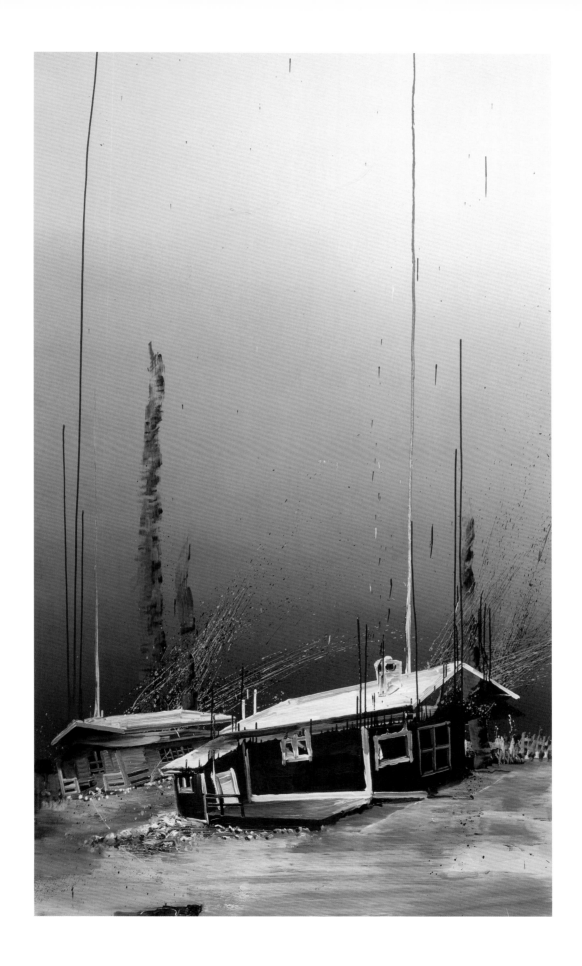

DIRK SKREBER
Untitled 1994
oil on canvas
158 x 191cm

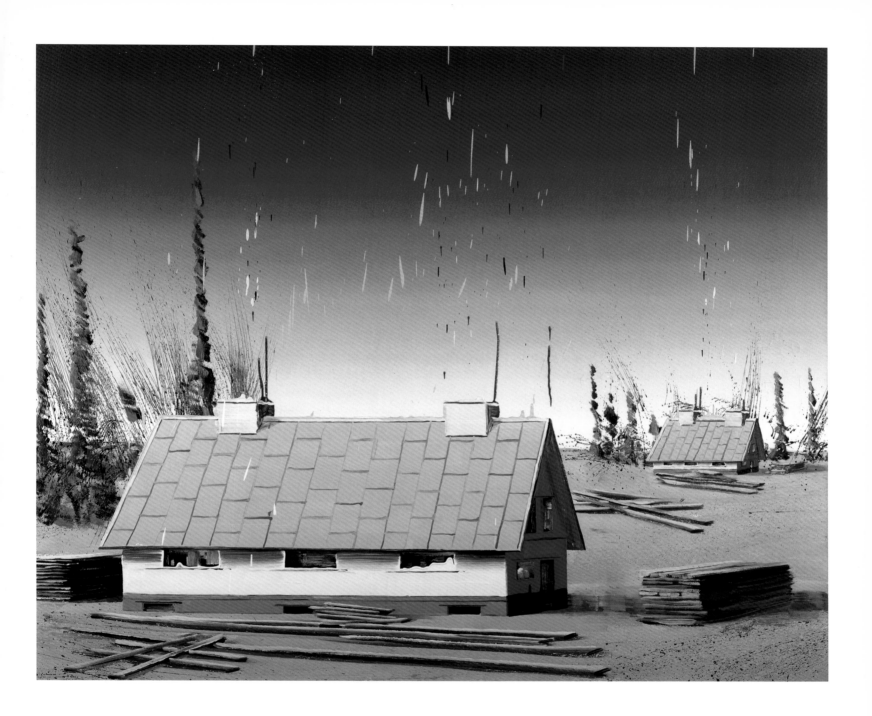

DIRK SKREBER
Tesa-Moll Seele 2004
foam and tape on wood
330 x 350cm

DIRK SKREBER
Untitled 2003
foam and tape on wood
250 x 150cm

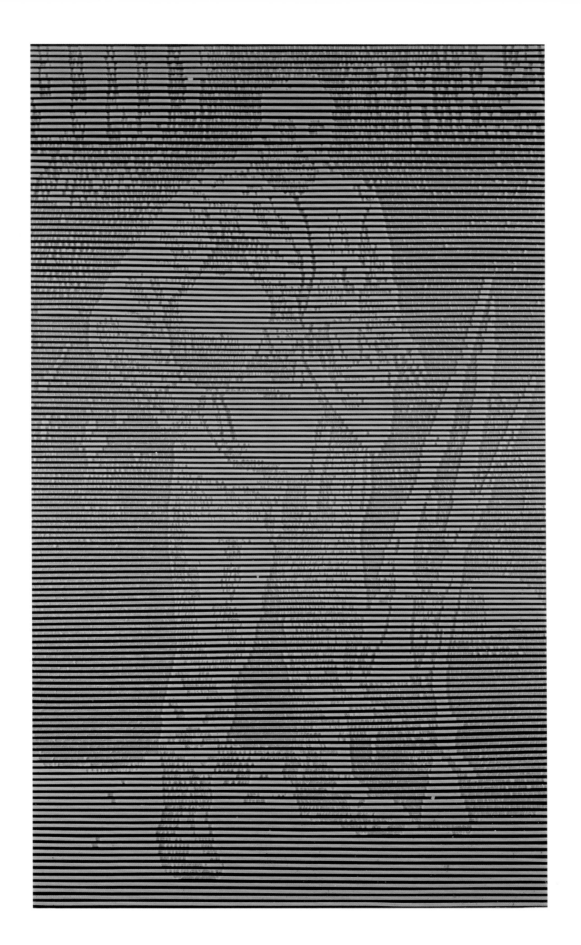

FRANZ ACKERMANN
Mental Map: Evasion V 1996
acrylic on canvas
274.5 x 305cm

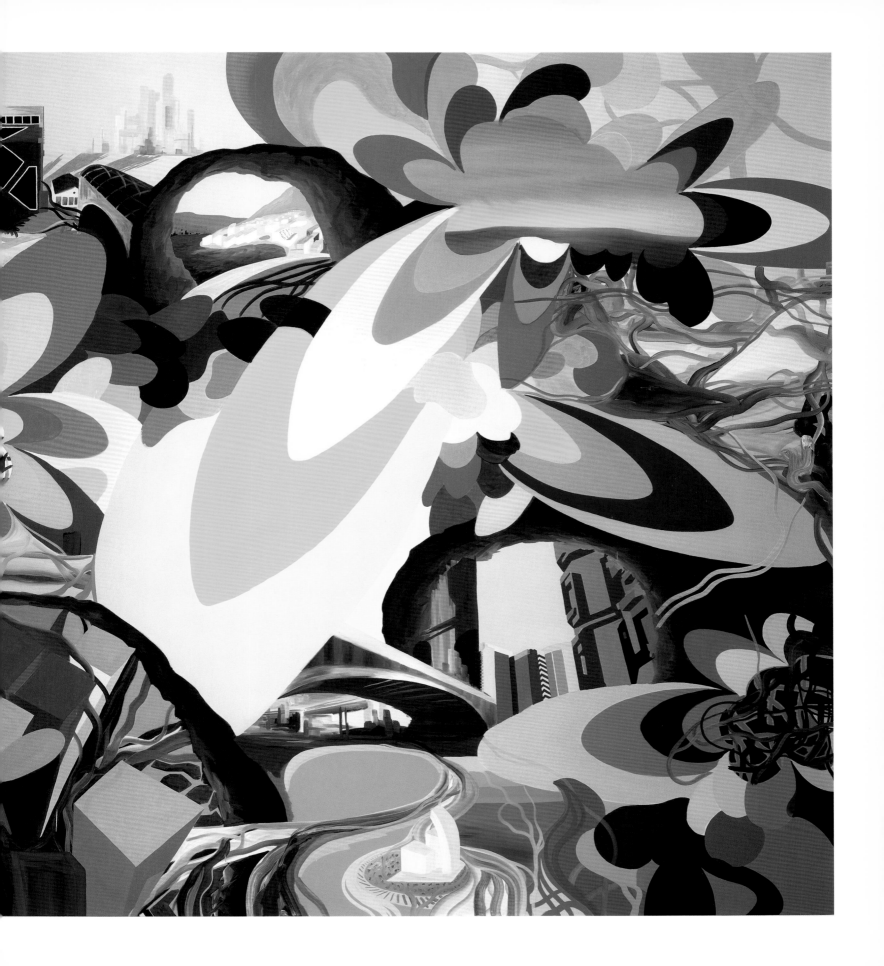

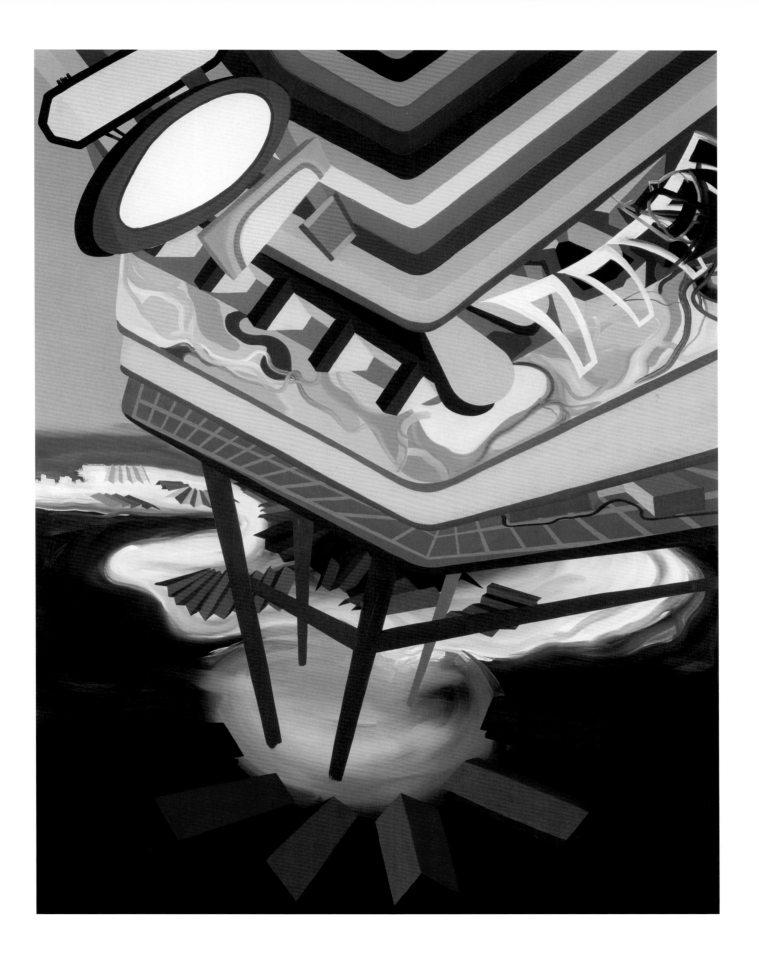

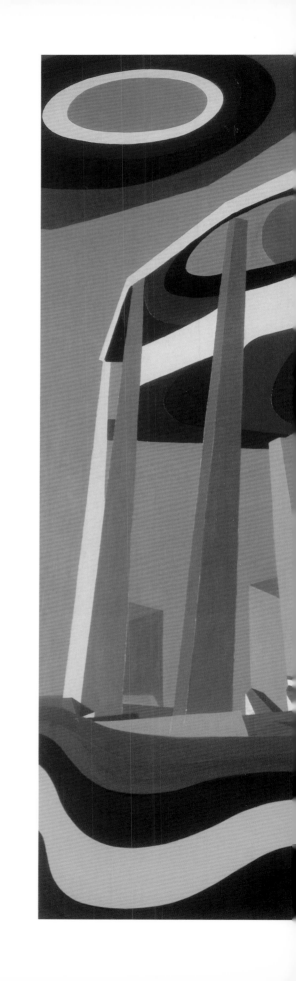

FRANZ ACKERMANN
Zooropa 2001
oil on canvas
200 x 250cm

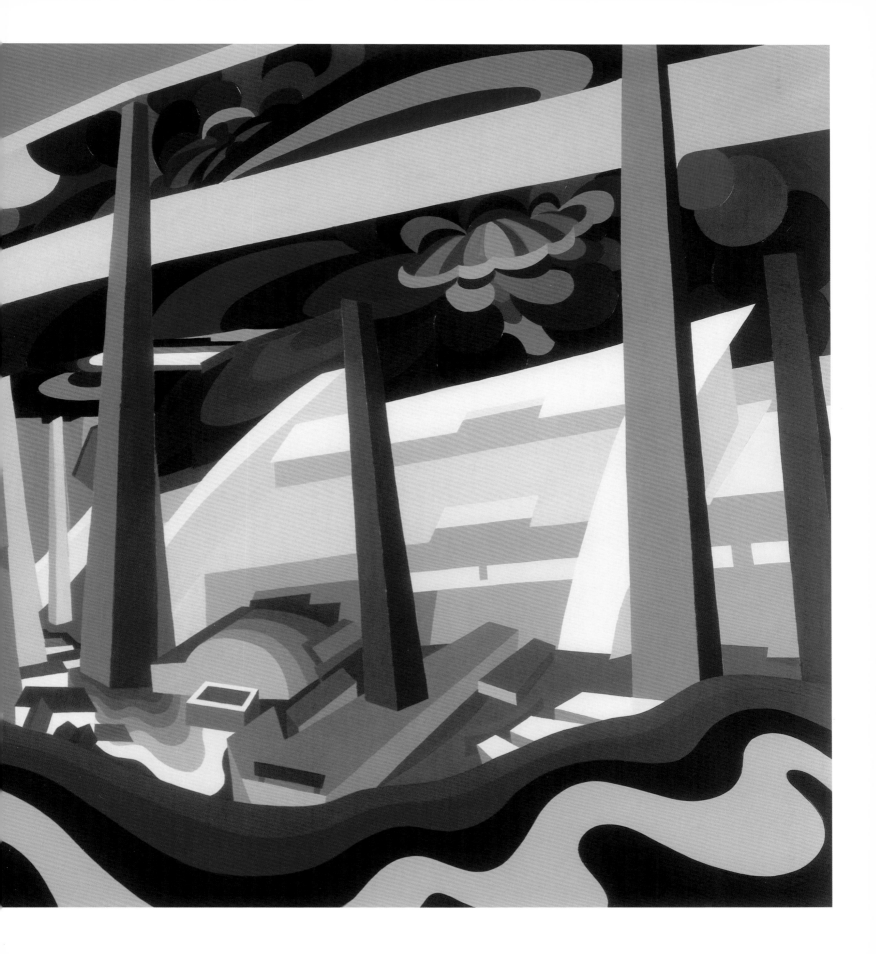

FRANZ ACKERMANN
Mental Map: Evasion VI 1996
acrylic on canvas
195 x 210cm

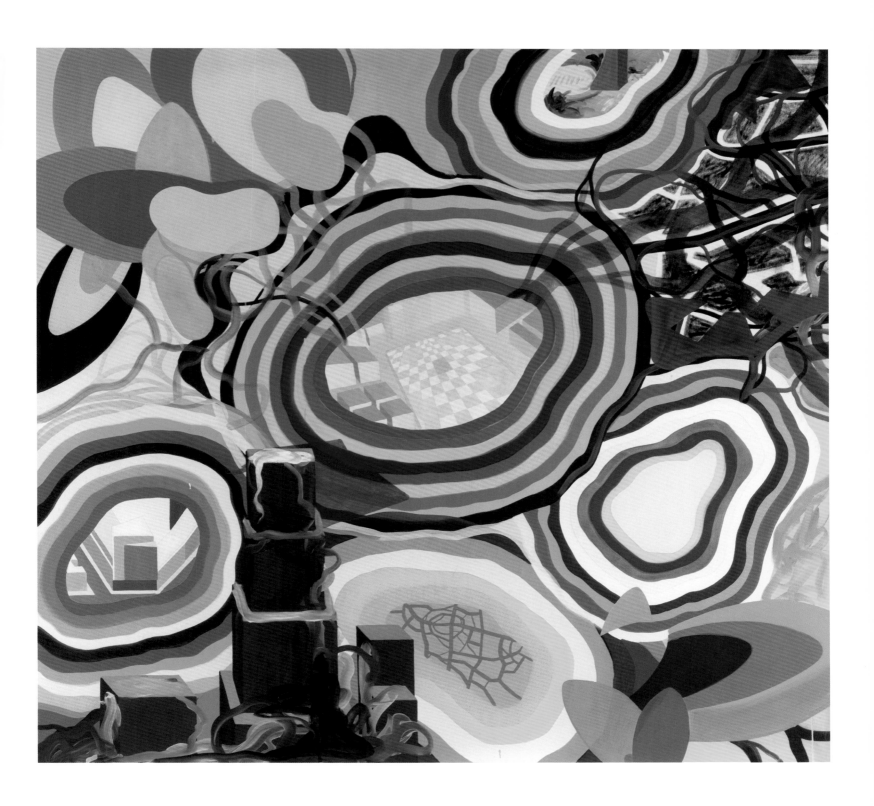

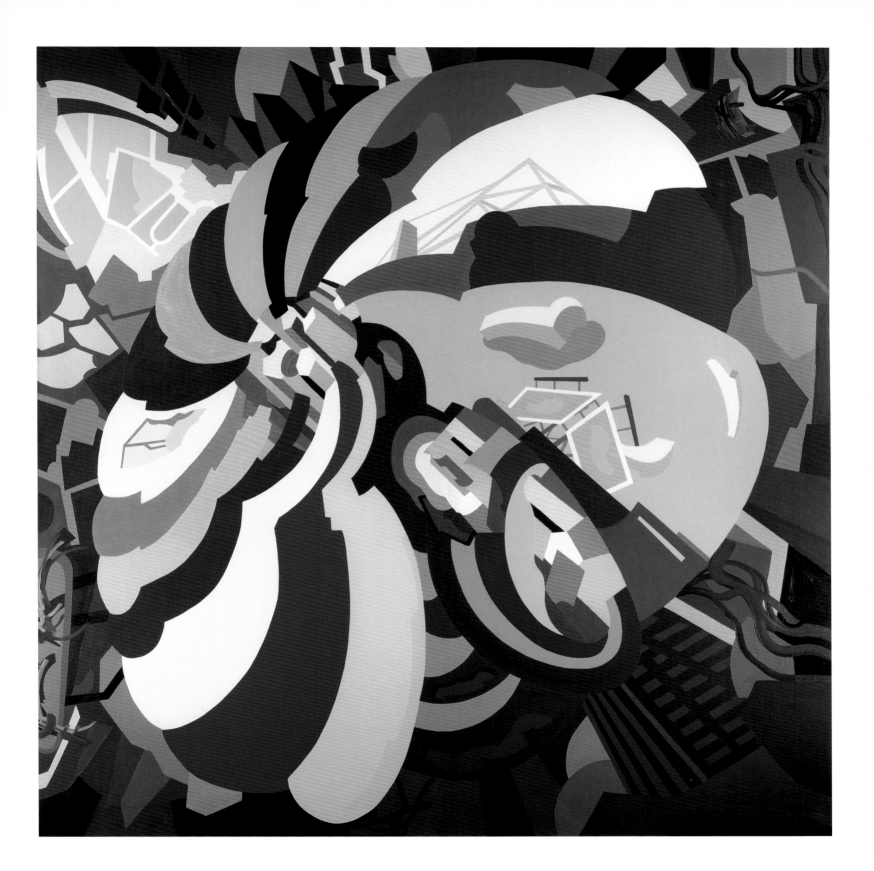

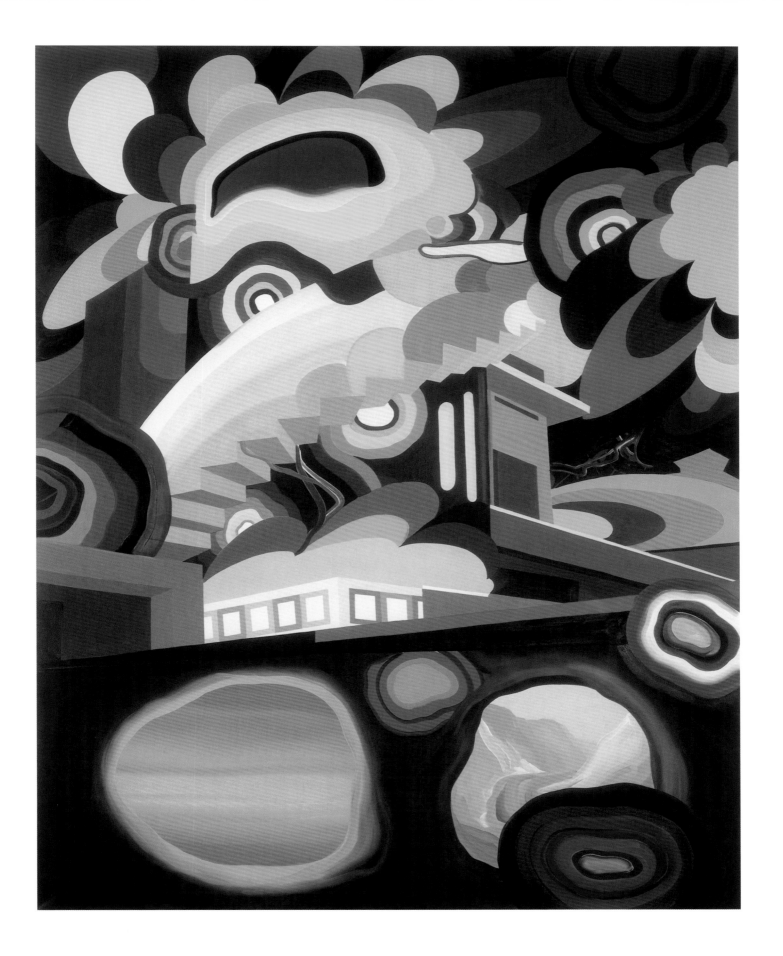

ARTISTS

ALBERT OEHLEN

'Because we now refuse to deny the direct dependence and responsibility of art vis-à-vis reality, and on the other hand see no chance for art as we know it to have an effect, there is only one possibility left: failure.' Oehlen

Albert Oehlen studied with Sigmar Polke in Hamburg in the 1970s and emerged in the early 80s, along with contemporaries Martin Kippenberger, Georg Herold and Werner Büttner as part of a generation acting in critical and often comedic contradiction to the predominant ideology of the time.

At the heart of Oehlen's practice is a serious engagement with the history of painting and a radical political opposition to its hierarchies and values. Redefining the consequence of painting in a post-painterly era, he describes his work as 'post-non-representational'. Through exploring and challenging the tropes and expectations of traditional abstraction, he strives to reconstitute a contemporary meaning for art as an independent articulate form.

Oehlen's work is wide-ranging in media and style, amalgamating figurative, abstract and layered elements to broaden the scope of painting. His most recent works are often produced through computer-generated design, incorporating collaged photographic and printed elements as a means to explore new territories of representation and reception. By adopting the 'unprofessional' qualities of collage, he shuns traditional criticism and defines his work by the limitations of its own construction.

Oehlen's paintings are neither beautiful nor seductive. Instead, they are elaborate strategies of provocation. Their self-consciously brutal surfaces seem to be corrupted from within, a perversion of the paintings they might have been.

Working from an ironic position of failure, he uses abstraction as a metaphor for breakdown: of perceived reality, artistic function and aesthetic affect. Oehlen's paintings offer a raw confrontation with the deficiencies of visual language and illustrate its trappings in their making.

BIOGRAPHY

1954 Born in Krefeld, Germany
 Currently lives and works in Bizkaia, Spain
1978 Hochschule für Bildende Kunst, Hamburg, BA

SELECTED SOLO EXHIBITIONS

2005 *Spiegelbilder 1982-1985* Max Hetzler, Berlin
2004 Musée Cantonal des Beaux-Arts, Lausanne
 The Good Life Nolan / Eckman Gallery, New York
2003 Alfonso Artiaco, Naples
2002 Galerie Nathalie Obadia, Paris
 Galerie Max Hetzler, Berlin
 Galerie Catherine Bastide, Brussels
 Painting and Collages Patrick Painter Inc, Santa
 Monica
2001 *Self Portraits* Skarstedt Fine Art, New York
 Checkers Galerie Baerbel Graesslin, Frankfurt
2000 Galerie Max Hetzler, Berlin
 Patrick Painter Inc, Santa Monica
1999 *Lord, Pferdeflusterer, Antichrist* Galeria Juana de
 Aizpuru, Madrid
1998 Galerie Mikael Anderson, Copenhagen
 Margo Leavin Gallery, Los Angeles
1997 Stedelijk Museum, Amsterdam
 Baladas Heavy Galerie Gisela Capitain, Cologne
1996 *Obras Recientes* Galeria Juana de Aizpuru, Madrid

SELECTED GROUP EXHIBITIONS

2005 *Groundswell* MOMA, New York
2004 *Pixels* Stellan Holm Gallery, New York
 *Hot Ice: Recent Painting from the Scharpff
 Collection* Kunstalle, Hamburg
2003 *Biennale d'Art Contemporain de Lyon* Lyon
 *Painting Pictures: Painting and Media in the Digital
 Age* Kunstmuseum Wolfsburg, Germany
2000 *Painting on the Move* Kunstmuseum, Basel
 Glee: Painting Now Palm Beach Institute of
 Contemporary Art, Lake Worth, Florida
1999 *Decades in Dialogue* Museum of Contemporary Art,
 Chicago
 Digital Sites Numark Gallery, Washington
 Sammlung Essl: The First View Klosterneuburg,
 Vienna
1998 *Recollection* Kunstverein, Graz
 Georg Herold / Albert Oehlen Galerie Max Hetzler,
 Berlin
 Selbstportraits Galerie Barbel Grasslin, Frankfurt
 Fast Forward Archives Kunstverein, Hamburg
1997 *Display* Charlottenborg Exhibition Hall, Copenhagen
1996 *On Paper II* Schmidt Contemporary Art, St Louis
 Peinture-Peinture Galerie Samia Saouma, Paris
 Provins – Legende Museet for Samtidskunst,
 Roskilde

THOMAS SCHEIBITZ

Berlin-based artist Thomas Scheibitz blurs the boundaries between painting and sculpture, and is often described as a 'post-cubist'. Recognisable imagery of landscape, architecture and still life appear within his abstracted canvases. Broken and fragmented, these images are deconstructed to mere formalist devices: geometric shapes, organic masses and flat colourful components from which he creates highly distorted spatial illusion.

Scheibitz works from an expansive image bank containing thousands of impersonal pictures collected from media sources. He uses painting as a means to explore the network of cultural signifiers of public consciousness. Painting from artificial representations, Scheibitz deconstructs the original image even further. His work operates as a lexicon for the interpretation of fast-paced consumer society.

Scheibitz's paintings celebrate the collective over the individual. Through abstraction, he offers a futuristic vision where nature and technology merge and realism is replaced by the higher aesthetic truth of pop design.

Broken down into utilitarian components of colour and shape, Scheibitz strips his subjects of all extraneous detail and reconstitutes them as pure information. Banal subjects such as houses, plants and mountains are made to seem uncanny and emotionally isolating. They are not representations but ideals: prototypical, pristine and cognitively interconnected.

Simultaneously familiar and strange, his paintings operate like memory: each pure idea is interrupted and displaced by a cacophony of visual language and associated information. Design, illustration, Japanese comics and traditional painting all play a part in Scheibitz's consumerist reference. Through painting, he freeze-frames the supersonic blur of twenty-first century zeitgeist for intimate contemplation. Breaking down the information overload like a handcrafted digital matrix, Scheibitz maps out blueprints to navigate the modern world.

BIOGRAPHY

1968	Born in Radeberg, Germany
	Currently lives and works in Berlin
1991-96	HfBK Dresden, Diploma
1995	Scholarship from the Studienstiftung des Deutschen Volkes
1996-98	HfBK Dresden, MFA
1998	Hegenbarth Scholarship

SELECTED SOLO EXHIBITIONS

2005	*51st Venice Biennale* German Pavilion (with Tino Sehgal)
2004	*Brot & Spiele* Tanya Bonakdar Gallery, New York
	Galeria Fortes Vilaça, São Paulo
	ABC I II III Centre d´Art Contemporain, Genf
2003	*diamondpaper* DiG, Berlin
2002	*Thomas Scheibitz: Hannibal ad portas* Produzentengalerie, Hamburg
	Maus Appetit Dezember Tanya Bonakdar Gallery, New York
	ART PACE San Antonio, Texas
2001	*Thomas Scheibitz* Works on Paper Inc., Los Angeles
	I-geometrica B, Matrix 195 Berkeley Art Museum, San Francisco
	BANNISTER DIAMOND Stedelijk Museum, Amsterdam
	Ansicht und Plan von Toledo Museum der Bildenden Künste, Leipzig
2000	*Surrogate* Galerie Gebr. Lehmann, Dresden
1999	*Final Gold* Tanya Bonakdar Gallery, New York
	Low Sweetie ICA, London
1998	Bonakdar Jancou Gallery, New York
1997	*Digitalin* Galerie Gebr. Lehmann, Dresden

SELECTED GROUP EXHIBITIONS

2005	*Estrangement proche/ Seltsam Vertraut* Saarland Museum, Saarbrüken
2004	*Saõ Paulo Biennale*, São Paulo
	The stars are so big, the earth is so small... stay as you are (part I) Galerie Schipper und Krome, Berlin
	Art contemporain, de 1960 à nos jours Centre Pompidou, Paris
2003	*Supernova: Art of the 1990s from the Logan Collection* Museum of Modern Art, San Francisco
	Painting on Sculpture Tanya Bonakdar Gallery, New York
	4ever Young Sommer Contemporary Art, Tel Aviv
	Matisse and Beyond San Francisco Museum of Modern Art
	Architecture Schmarchitecture Kerlin Gallery, Dublin
2002	*German Expressions* Albright-Knox Art Gallery, Buffalo
	Artist Imagine Architecture ICA, Boston
2001	*Berlin - London 01* ICA, London
	Musterkarte - Modelos de Pintura Centro Cultural Conde Duque, Madrid
	Painting at the Edge of the World Walker Art Center, Minneapolis
2000	*Collectors' Choice* Exit Art, New York
1999	*Examining Pictures* Whitechapel Art Gallery, London
	Drawings Bonakdar Jancou Gallery, New York

WILHELM SASNAL

Wilhelm Sasnal is one of the most celebrated artists to emerge from Eastern Europe in recent years. Working from his home country Poland, he uses painting as a means to intimately negotiate his position within (new) capitalist culture. Sasnal's work is prolific, varied and deliberately unclassifiable as a strategy: digesting his practice is akin to swallowing mass media whole.

Sasnal draws his subject matter from day-to-day reality. The most banal examples of still life mingle with commensurate importance to propaganda icons, advertising and photojournalistic imagery. Sasnal approaches image production as a formal exercise, ranging from abstract to figurative with schizophrenic adaptation of style and technique. Through making, he renders all things equal.

For Sasnal, painting is imperative as a means of challenging traditional expectations of representation and perception. Through his intervention, subject matter becomes distorted: images are pared down to the bare essentials and estranged from their original context or meaning.

Stripping authority of its power, Sasnal renders the political as defunct and the irrelevant as intrinsic. A suicide bomber's belt sits innocuously next to an image of a pop star, an agitprop photo of factory workers is given a Warholian edge and a Soviet sculpture is cropped and repainted as pure decoration. Using a predominantly black-and-white palette, Sasnal approaches painting as a reductive process. Information is lost in translation and replicated images only exist as mere vestiges of themselves.

Sasnal's practice doesn't celebrate freedom, but a shift in conformity. It strives to define personal experience of an impersonal world. Through his painting, he explores a no man's land where private and public converge in a sluice of shared memory. Operating as his own self-sustaining information source, Sasnal imposes his world order on politics, celebrity, art history and banality, quietly developing a position of individual conscience.

BIOGRAPHY

1972	Born in Tarnow, Poland
	Currently lives and works in Tarnow
1999	Graduated from Krakow Academy of Fine Art
1996-2001	Co-founder and member of Ladnie Group

SELECTED SOLO EXHIBITIONS

2004	*Wilhelm Sasnal: The Band* Hauser & Wirth, Zürich
	Zawa Srod Galerie Johnen & Schöttle, Cologne
2003	Westfälischer Kunstverein, Münster
	Kunshalle Zürich, Zürich
2002	Galerie Johnen & Schöttle, Cologne
	Foksal Gallery Foundation, Warsaw
	Parel, Amsterdam
2001	*Cars and Men* Galeria Foksal, Warsaw
	Everyday Life in Poland between 1999 and 2000 Galeria Raster, Warsaw
2000	*Accident* Bagat Showroom, Warsaw
	Board Game Galeria Potocka, Krakow
1999	*One Hundred Pieces* Galeria Zderzak, Krakow
	Crowd Open Gallery, Krakow
	Painting CCA Ujazdowski Castle, Warsaw
1998	*A National Holiday* Galeria Otwarta, Krakow
	Private-Public Open Gallery, Krakow

SELECTED GROUP EXHIBITIONS

2004	Camden Arts Centre, London (with Ben Ravenscroft, Sam Basu & Michael Marriott)
	Map Trap Galeria Raster, Warsaw
	T-ow Anton Kern Gallery, New York
2003	*Wisla* Sommer Contemporary Art, Tel Aviv
	3 O'clock Road Block Sadie Coles HQ, London
2002	Kunsthalle, Basel
	Kwangju Biennale Kwangju, Korea
	Urgent Painting Musée d'Art Moderne de la Ville de Paris, Paris
2001	New Collection of the CCA and the Loan of the Foksal Gallery, CCA
	Ujazdowski Castle, Warsaw
	The Good Galeria Raster, Warsaw
	Tirana Biennale Tirana, Albania
	Bureaucracy Galeria Foksal, Warsaw
	Pop-elite Bunkier Sztuki, Krakow
	In Between Chicago Cultural Center, Chicago
	Fisheye BWA gallery, Slupsk
2000	*Scena 2000* CCA Ujazdowski Castle, Warsaw
	Visual Art - Simple Life Edit-Russ-Haus, Oldenburg
	100% Painting BWA gallery, Posen
	Paint Me BWA, Zielona Góra
1999	*What you see is what you get* Medium Gallery, Bratislava
1997	*Seven Young Painters* French Cultural Institute, Krakow

KAI ALTHOFF

Something sinister lies at the heart of Kai Althoff's paintings: unease with the way history repeats itself. Languages borrowed from traditional art are used to paint out suggestive narratives of the artist's own invention. Ranging from avant-garde collage to fairytale illustration, Althoff's appropriated styles carry the weight of historical authority. Blurring the boundaries between past and present, Althoff's paintings explore sensuality, violence and morality as timeless themes.

Central to Althoff's paintings is a longing for reconciliation, with German history, masculine identity and the politics of pack mentality. His all-male cast of characters gives credence to the corruptibility and heroism of youth. Soldiers, dandies, saints and sinners all take starring roles, playing out the group dynamics of power, violence, vulnerability, enticement and sentimentality.

The wholesome ethic of German Catholicism and 30s fascist-style design repeatedly serve to underscore Althoff's taboo subtexts of homosexuality and a nation's fractured history. Althoff only hints at his work's contemporary origin through the use of modern materials such as resin, tape and tinfoil.

Using a variety of media, Althoff draws sympathetic psychology from the physicality of his surfaces. Oil paint is applied with provocative sensuality, giving a tender eroticism to images of brutality. A collage depicting religious repentance is rendered on translucent paper: a frail veneer of purity. Althoff presents beauty as an epitomised guise of perversion; his paintings are elaborate seductions of amoral acquiescence.

From long-forgotten wars to orgy-esque club-land, Althoff's paintings explore the essence of masculine experience. Unspoken histories of love, guilt and redemption are rendered with incredible poignancy. Through painting, Althoff designs his own contemporary mythology: by delving into the past, Althoff seeks ablution for the future. His paintings offer a quiet hope for the human condition.

BIOGRAPHY

1966 Born in Cologne, Germany
Currently lives and works in Cologne

SELECTED SOLO EXHIBITIONS

2004 *Kai Althoff: Kai Kein Respekt (Kai No Respect)*
Museum of Contemporary Art, Chicago; ICA,
Boston

2003 *Vom Monte Scherbelino Sehen* Diözesanmuseum,
Freising

2002 *Kai Althoff* (with Armin Krämer) Kunstverein
Braunschweig, Germany

2001 *Impulse* Anton Kern Gallery, New York; Galerie
Neu, Berlin
Aus Dir Galerie Daniel Buchholz, Cologne

2000 *Stigmata aus Grossmanssucht* Galerie Ascan
Crone, Hamburg
Hau ab, Du Scheusal Galerie Neu, Berlin

1999 Galerie Hoffmann & Senn, Vienna
Galerie Christian Nagel, Cologne

1998 *Reflux Lux* Galerie Neu, Berlin
Bezirk der Widerrede Galerie Daniel Buchholz,
Cologne

1997 *Hilfen und Recht der äußeren Wand (an mich)*
Anton Kern Gallery, New York
In Search of Eulenkippstadt Robert Prime Gallery,
London
Heetz, Nowak, Rehberger Museum of
Contemporary Art, São Paulo

1996 *Hakelhug* Galerie Christian Nagel, Cologne

1995 *Hast Du Heute Zeit - Ich Aber Nicht* Künstlerhaus,
Stuttgart
Modern wird lahmgelegt Galerie Daniel Buchholz,
Cologne

SELECTED GROUP EXHIBITIONS

2004 *Huts* Douglas Hyde Gallery, Dublin
*Dreams and Conflicts: The Dictatorship of the
Viewer* Venice Biennale

2003 *Chère Paintre, Liebe Maler, Dear Painter* Schirn
Kunsthalle, Frankfurt
A Perilous Space Magnani, London
actionbutton Hamburger Bahnhof, Museum für
Gegenwart, Berlin

2002 *Chère Paintre, Liebe Maler, Dear Painter* Centre
Pompidou, Paris; Kunsthalle Wien, Vienna
Drawing Now: 8 Propositions Museum of Modern
Art, New York

2001 *Drawings* Regen Projects, Los Angeles
Neue Welt Frankfurter Kunstverein, Frankfurt
*Musterkarte - Modelos de Pintura en Alemania
2001* Galeria Heinrich Erhardt, Madrid
I Love NY Anton Kern Gallery, New York

2000 *Premio Michetti* Museo Michetti, Francavilla al Mare,
Switzerland
00 Barbara Gladstone Gallery, New York
Galerie Daniel Buchholz, Cologne

1999 *German Open* Kunst Museum, Wolfsburg, Germany
How will we behave? Robert Prime Gallery, London
Oldnewtown Casey Kaplan Gallery, New York
Who, if not we? Elizabeth Cherry Contemporary
Art, Tucson, Arizona
On paper Stalke Galleri, Copenhagen
Ars Viva 98/99 - Installationen Portikus, Frankfurt
am Main

DIRK SKREBER

German artist Dirk Skreber works in sculpture, installation and painting. Ranging from the abstract to the representational, his work is concerned with the architecture of the hyper real: highly articulated constructions which reside in suspended space and time. His subject matter draws from the mundane flow of contemporary life: buildings, car crashes and natural disasters are treated with the most clinical formalism. His work offers the detached seduction of the sublime.

Often working in epic scale, Skreber's paintings monumentalise the banal. Figurative scenes of lone train carriages and road accidents aren't tableaux of narrative spectacles, but abstract incidents of incomprehensible beauty and horror. Rendered perfect in their making, their surfaces are impenetrable, exacting and serene; they don't offer spatial illusion, but vast fields of emptiness.

Skreber doesn't strive for photorealism; his work only borrows from the tropes of mechanical reproduction. The soft focus of advertising, aerial views of surveillance photography and image replication of print media are placebos of intimacy. Translated into painting, these devices serve as filters transforming the familiar into the uncanny.

Skreber uses the paint itself as a language of contradiction. Varying stylistically from seamless gradients to gestural rendering, his paintings don't offer pictorial illusion, but instead, exploit their own material qualities. Photography captures a single moment in time; Skreber's paintings are frozen in expectation.

In his more abstract work, Skreber transfers the sublime contemplation of modernism into a more frightening contemporary construct, where personal psychology is replaced by the public realm. Skreber presents trepidation as a normalised condition of collective consciousness, awe as a symptom of mass-media proliferation and spirituality as an achievement of design.

BIOGRAPHY

1961	Born in Lübeck, Germany
	Currently lives and works in Düsseldorf and New York
1982-1988	Studied at the Dusseldorf Art Academy, Dusseldorf
1994-1995	Visiting Fellow at the Karlsruhe Art Academy

SELECTED SOLO EXHIBITIONS

2004	*Na(h)tanz* Aspen Art Museum, Aspen
	Muss et Sin Engholm Engelhorn Galerie, Vienna
	Friedrich Petzel Gallery, New York
2003	*Painspotting* Blum & Poe, Los Angeles
2002	Kunstverein Freiburg, Freiburg
	Galleria Gió Marconi, Milan (with Björn Dahlem)
	Galerie Luis Campana, Cologne
	Galerie Elba Betinez, Madrid (with Björn Dahlem)
2001	Blum & Poe, Los Angeles
	Kerstin Engholm Galerie, Vienna
1999	Luis Campaña Galerie, Cologne
	Blum & Poe, Los Angeles
1998	Portfolio, Vienna
1997	Galerie Bochynek, Düsseldorf
	Leopold-Hoesch-Museum, Düren
	Luis Campaña Galerie, Cologne

SELECTED GROUP EXHIBITIONS

2005	*Present Perfect* Friedrich Petzel Gallery, New York
2004	*Claus Föttinger, Hans Schabus, Dirk Skreber* Sies + Höke, Düsseldorf
	raumfürraum Kunsthalle, Düsseldorf
	Now Is a Good Time Andrea Rosen Gallery, New York
	Art Chicago 2004, Chicago
2003	*Jetzt und Hier* Museum Kurhaus, Kleve
	4ever Young Sommer Gallery, Tel Aviv
	Blum & Poe, Los Angeles
	Das unHEIMliche in der zeitgenossischen Malerei Stadtische Galerie, Delmenhorst
2002	Permanent Collection, Museum für Moderne Kunst, Frankfurt
	Viewfinder Arnolfini, Bristol
2001	*Far from us*, Annet Gelink Gallery, Amsterdam
	EU Stephan Friedman Gallery, London
	Musterkarte Galerie Elba Benitez, Madrid
	Without Hesitation Neues Museum, Weserburg, Bremen
2000	*Hypermental* Kuntshaus, Zürich
	Barbara Gladstone Gallery, New York
1999	Jeffrey Deitch Projects, New York
	Kerstin Engholm Galerie, Vienna
1998	Galerie Bochynek, Düsseldorf
1997	*Surprise II* Kunsthalle, Nürnberg

FRANZ ACKERMANN

German artist Franz Ackermann is a perpetual tourist, but not of the ordinary kind. He is on a quest for exotica in the twenty-first century: actively seeking cultural differences, he travels the corners of the globe, searching for the 'unknown'. Asia, the Middle East and South America are perceived as destinations of adventure where a disquieting shift towards sameness engenders feelings of discomfort and alienation.

Ackermann describes his paintings as 'mental maps'. Each kaleidoscopic canvas readily depicts his experience of place. The geometric compositions offer both a topographical geography and an emotive record of his thoughts and feelings on each location.

Inspired by the phenomena of urban generation, globalisation and cultural commodification, Ackermann's paintings adopt the modern superficiality of pop. Festive colours beacon with package-holiday promise, merchandising traditional ways of life as luxurious folly. Shapes and patterns spiral out of control, topsy-turvy buildings contort as perilously as property developers' investments, landscapes are swallowed up by industrial vortexes and nature fights back with toxic sunsets and concrete waves.

As maps, Ackermann's paintings take on an all-too-familiar surrealism. Rendered with clumsy cartography, geography itself becomes unsettled. Masses twist awkwardly in time and space, unable to keep up with the concept of technological speed, the miniaturisation of the globe through supersonic flight and mass-media buzz.

Through his visual travelogues, Ackermann offers a provocative record of an ever shrinking planet. Digesting the subtle nuances of popular destinations, he regurgitates them as international signifiers: brightly coloured shapes, high-impact graphics and pop iconography. Each place becomes a logoised 'non-place', a triumph of marketing over cultural difference, national identity and natural exoticism.

BIOGRAPHY

1963	Born in Neumarkt St Veit, Germany
	Currently lives and works in Berlin
1984 - 1988	Akademie der Bildenden Künste, Munich
1989 - 1991	Hochschule für bildende Kunst, Hamburg

SELECTED SOLO EXHIBITIONS

2004	*nonstop with the hhc* Gavin Brown's enterprise, New York
	travelantitravel neugerriemschneider, Berlin
2003	*Naherholungsgebiet* Kunstmuseum, Wolfsburg
	Eine Nacht in den Tropen Kunsthalle, Nürnberg
2002	*Basel Public* Wandinstallation Nordtangente, Basel
	The Waterfall Museum of Contemporary Art, Chicago
	Seasons in the sun Stedelijk Museum, Amsterdam
2000	*B.I.T.* Castello di Rivoli, Turin
	welt 1... and no one else wanted to play Meyer Riegger Galerie, Karlsruhe
1999	*OFF* Kasseler Kunstverein, Kassel
	Trawler Mai 36 Galerie, Zürich
1998	*Pacific* White Cube, London
	Songline Neuer Aachener Kunstverein, Aachen
1997	*unexpected* Gavin Brown's enterprise, New York
	unerwartet Portikus, Frankfurt
1996	*Das weiche Zimmer* neugerriemschneider, Berlin

SELECTED GROUP EXHIBITIONS

2005	*Works on Paper* Galerie Max Hetzler, Berlin
	Colours and Trips Künstlerhaus Palais, Thurn
2004	*Champs de vision* Musée des Beaux Arts, Rouen
	Monument to now Deste Foundation for Contemporary Art, Athens
2003	*A New Modernism For A New Millennium: Abstraction and Surrealism Are*
	A Nova Geometria Galeria Fortes Vilaça, São Paulo
	Un-built cities Bonner Kunstverein, Bonn
	Supernova: Art of the 1990s from the Logan Collection Museum of Modern Art, San Francisco
	Hands up, baby, hands up! Oldenburger Kunstverein, Oldenburg
	Global Navigation System Palais de Tokyo, Paris
2003	*Dreams and Conflicts - The Viewer's Dictatorship* Venice Biennale
2002	*Psychodrome 02* Fundació Juan Miró, Barcelona
	En Route Serpentine Gallery, London
	8th Baltic Triennial of International Art Contemporary Art Centre, Vilnius
	Drawing now – eight positions Museum of Modern Art, Long Island City
	XXV Bienal de São Paulo, São Paulo
2001	*Arte Contemporáneo Internacional* Museo de Arte Moderno, Mexico
	EU Stephen Friedman Gallery, London
	Hybrids Tate Liverpool, Liverpool

Published by The Saatchi Gallery and Koenig Books London

Deutsche Bank ▨
Corporate Patron Deutsche Bank

ISBN: 3-88375-973-2

Published and distributed by Koenig Books London at the Serpentine Gallery, Kensington Gardens, London, W2 3XA
www.koenigbooks.co.uk

Distribution outside Europe by DAP Inc, 155 Sixth Avenue, New York, NY 10013
Tel: 001 212 627 1999
Fax: 001 212 627 9484

Printed by Specialblue, London, E3

www.saatchi-gallery.co.uk